I hope thi[s] [helps]
you to get your London book
done, so we can spend
more days in Madison
— Julie

Constable's 'English Landscape Scenery'

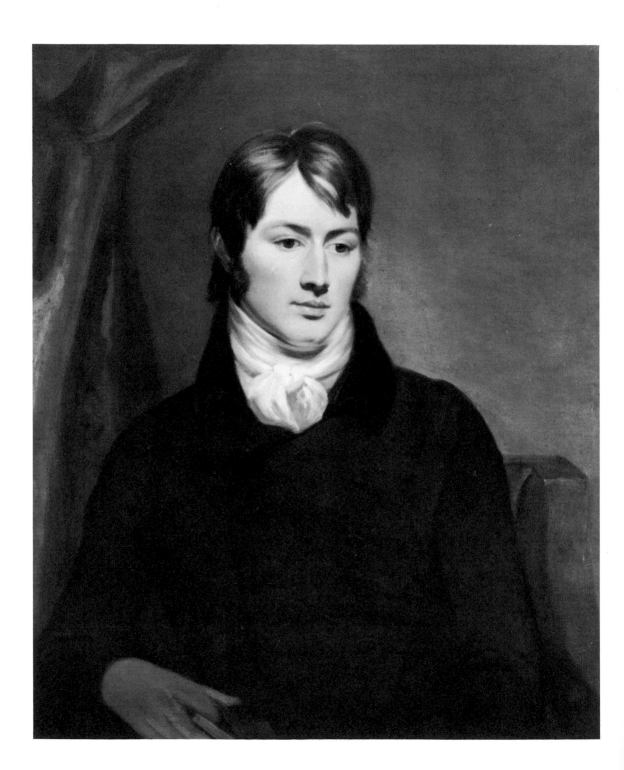

British Museum Prints and Drawings Series

Constable's 'English Landscape Scenery'

Andrew Wilton

A Colonnade Book

Published by British Museum Publications Limited

Colonnade books
are published by British Museum Publications Ltd
and are offered as contributions to the enjoyment,
study and understanding of art, archaeology and
history.

The same publishers also produce the official
publications of the British Museum.

© 1979 Andrew Wilton

ISBN 0 7141 8010 6 cased

Published by British Museum Publications Ltd,
6 Bedford Square, London WC1B 3RA

Designed by James Shurmer

Set in Monotype Garamond by Filmtype Services,
Scarborough and printed in Great Britain by
W.S. Cowell Ltd., Ipswich and London.

Cover: Salisbury Cathedral

Frontispiece: Portrait of Constable in oil by Richard
Reinagle (National Portrait Gallery).

Contents

Constable's 'English Landscape Scenery'

In June 1830 there appeared the first issue of a series of mezzotint plates entitled *Various Subjects of Landscape, Characteristic of English Scenery, From Pictures Painted by John Constable, R.A.* This work was the only attempt that Constable made in the course of his career to gain a wider public for his art than that which saw and bought his pictures at the London exhibitions. He financed it himself, and, although it was by no means successful, he issued a second edition in 1833, in which the plates were the same as those in the first edition, though rearranged. But Constable had radically altered the significance of his publication by adding his own commentaries on a number of subjects, and, even more pointedly, by modifying the title; it was now *Various subjects of Landscape, characteristic of English Scenery, principally intended to mark the Phenomena of the Chiar' Oscuro of Nature.* The general survey of his work that was his first edition was transformed into a related series of illustrations to a particular theme.

One of his most important achievements was his successful championship of naturalism in painting: he rejected the conventions of artificiality that led Sir George Beaumont to demand that a landscape be the colour of an old violin–to which Constable's answer was to place a violin on Sir George's lawn[1]–and he said: 'My pictures will never be popular, for they have no *handling*. But I do not see *handling* in nature.'[2] It is his freedom from mannerism, from preconceptions derived from the work of other artists, that distinguishes Constable at his best from, say, Turner, who all his life chose to express himself in a theatrical language of 'High Art' rather than in the simple, direct recording of nature.

It is therefore rather surprising that when Constable came to give a more explicit and public expression to his ideas, he built it around a concept that was characteristic of the old tradition of painting, from the sixteenth century onwards. By using the term 'chiaroscuro' he invoked the principle of composition by means of the alternation of light and shade, and particularly the exaggerated effects of darkness shot through with brilliant light that we associate with the works of Correggio and Rembrandt. It was a method of picture-construction that was, in Constable's time, revolutionised by Turner's more dynamic and chromatic use of light, and had already been dismissed as 'Blots & Blurs' in the obscure fulminations of William Blake, who may speak for the more extreme of the Neo-Classicists.[3] Constable, much more than Turner, anticipated the fresh, informal approach to nature of the Impressionists; but he did not, like Blake, disapprove of Rembrandt. He admired the famous *Mill* (in the National Gallery of Art, Washington, Widener collection – now considered to be an imitation) as 'a picture wholly made by chiaroscuro; the last ray of light just gleams on the upper sail of the mill, and all other details are lost in large and simple masses of shade. Chiaroscuro is the great feature that characterises his [Rembrandt's] art'.[4]

But Constable's 'chiaroscuro' was not so naively extreme as that example. Chiaroscuro, he said, 'is by no means confined to dark pictures; the works of Cuyp, though generally light, are full of it'.[5] And he went on to give a definition of chiaroscuro as 'that

power which creates space; we find it everywhere and at all times in nature; opposition, union, light, shade, reflection, and refraction, all contribute to it. By this power, the moment we come into a room, we see that the chairs are not standing on the tables, but a glance shows us the relative distances of all the objects from the eye, though the darkest or the lightest may be the farthest off . . .'[6]

This is to define chiaroscuro almost out of existence; Constable seems to mean little more than 'tonal variation', a phenomenon undeniably present both in the real world and in all paintings of it. The quotation that he chose to use in his description of the plate of 'Spring' in the *English Landscape Scenery* sums up this definition, but also shows that Constable felt that contrasts of tone were an essential and characteristic feature of the countryside:

. . . light and shade alternate, warmth and cold,
And bright with dewy clouds, and vernal show'rs,
And all the fair variety of things.

On the other hand, in the letterpress that he composed for 'Dedham Mill', he admits that 'the subject of this print is little more than an assemblage of material calculated to produce a rich Chiar Oscuro, and is noticed solely with that view.' (It is almost the only plate which does not derive from an already existing work.)

There was, then, something artificial in the conception of the series of views of *English Landscape Scenery* that he embarked on in 1829 with the young mezzotinter David Lucas. It might even be argued that the medium he chose, mezzotint, was one peculiarly associated with the production of painterly, rather than natural effects. It was certainly well suited to rendering the vigorous impasto by which Constable expressed the perpetual motion of nature; but its sharp contrasts of velvety blackness and white light were, one would imagine, quite alien to the fresh daylight in which Constable generally saw landscape.

There are two reasons why Constable may have been drawn to the medium of mezzotint; one is connected with his own development as an artist, the other stems from external circumstances.

It has often been remarked that, in his later years, Constable's view of the world darkened. The death of his wife in the November of 1828 after only twelve years of marriage, hardly compensated for by a long-delayed and rather grudging professional recognition in his election to the status of Royal Academician in 1829, cast a shadow over the remaining decade of his career—he died in 1837. His works of that time have been seen as more sombre and stormy than any he produced before. His interest in dramatic natural effects—dark clouds, lightning, rainbows—intensified, and a lowering mood of pessimism came to characterise his compositions. It might even be said that something of the Turnerian 'artificiality'—at least his theatricality—had rubbed off on Constable by this date, just as it is possible to see elements of Constable's later style in some works of Turner in the years immediately after Constable's death. To render such dramatic subjects in black and white, mezzotint was the obvious choice. In fact, the majority of the compositions that he chose for the work dated from earlier in his career, and do not partake of the later, more serious mood; but Constable was able to give them additional force by applying to them the effects typical of mezzotint.

English Landscape Scenery was nevertheless intended to include scenes of contrasting types; it had an underlying deliberate, quasi-didactic plan which is only partly evident in

8

the published issues, but which clearly guided Constable in many of the decisions he made, and which points to the second of his reasons for choosing mezzotint as his medium.

There was an obvious and immediate precedent for the publication of a selection of subjects by one artist in periodical issues: the famous *Liber Studiorum* of Turner (1775–1851) which had appeared in fourteen parts between 1807 and 1819.[7] As its title implied, Turner's *Liber* was inspired by the *Liber Veritatis* of Claude Lorrain (1600–82). This consisted of drawings, in pen and wash, of the subjects of all Claude's pictures, a working record of everything he produced. In the 1770s the *Liber Veritatis* drawings (then in the collection of the Duke of Devonshire) were published by John Boydell in the form of mezzotints with etched outlines, imitating the pen-and-wash drawing technique of Claude. These were executed by the engraver Richard Earlom, and it was Earlom's prints that Turner had in mind when he conceived his *Liber Studiorum* as a sequence of small-scale reproductions of his own pictures. Turner actually etched many of the outlines himself, employing engravers to add the mezzotint tone. The technique of the *Liber* plates had been reproduced very closely in a more recent publication: George Arnald's set of views of *The River Meuse . . . from the City of Liège to that of Mézières . . .*, which appeared in 1828.[8] Turner's intention was to demonstrate the range of his branch of art landscape – embracing historical, marine, mountainous, architectural and pastoral subjects, which he indicated by an initial letter above each print. In doing so he proclaimed, too, his acceptance of a traditional classification of landscape into clear categories; this was typical of his strongly academic, historically-orientated temperament.

Constable's own art was, as we have said, quite unlike Turner's in this respect: it did not embrace a vast range of subject-matter, nor did it look back to academic precedents and traditional labels. Constable, goaded by financial worries and repeated frustrations in his work on the *English Landscape Scenery*, once referred to Turner's *Liber Stupidorum*;[9] but he was far from being unaware of Turner's achievement and his publication was evidently modelled in many respects on the *Liber*. He spent much time, for instance, arranging the plates in different sequences so that each issue of four prints should present a balance of landscape types just as Turner's five-print issues did. His draft arrangements are annotated with a code indicating the categories: p,f,L and g are the four principal ones, perhaps standing for pastoral, fancy, lyrical, and grand, though the subjects themselves hardly bear such classification and were moved, apparently arbitrarily, from one category to another in different drafts, to suit the layout. There is also one 'H', presumably standing for 'historical'.[10] Elsewhere, Constable refers to 'every walk of landscape, historic, poetic, classic, and pastoral'.[11] The code does not fit these descriptions precisely, but however Constable may have intended to classify his subjects, it is clear that some such system of pre-ordained landscape types was in his mind, and this makes the connection with the *Liber Studiorum* quite plain.

Granted that connection, his decision to use mezzotint follows naturally. He had already had some contact with one of the greatest mezzotinters of the time, Samuel William Reynolds (1774–1835), who had offered to engrave his picture of *The Lock* in 1825.[12] This was a surprising mark of respect from a distinguished engraver to an artist whose work had not, at that date, been much reproduced. Reynolds was contracted to make mezzotints of some of Constable's drawings in 1824, but the artist's friend John

Fisher objected: 'There is, in your pictures, too much evanescent effect, and general tone, to be expressed in black and white. Your charm is colour, and the cool tint of English daylight. The burr of mezzotint will never touch that.'[13] Reynolds worked mostly from portraits, by artists such as his namesake Sir Joshua; but he also issued prints after Rembrandt and George Morland, both artists whose style gave the mezzotinter an opportunity to exploit the capacity of his medium to render the effect of full impasto. This, together with the richness of its black/white contrasts, may have been for Constable an acceptable substitute for 'colour';[14] at the same time it parallels in the medium of the print his exploration of the surface texture of paint as a means of conveying the restless or, as he was fond of describing it, 'fitful' quality of English light.

In 1820, Reynolds had taken as apprentice a young man of eighteen whose talent at drawing he had admired; this was David Lucas,[15] who probably collaborated with him on the unfinished plate of *The Lock*, and was to make another plate of the same composition on his own account in 1835. Constable would then have known of, or even met, Lucas, who might well have presented himself as the obvious choice for the task of engraving *English Landscape Scenery*, even though he had not produced any work of importance since his apprenticeship ended in 1827, and it is known that Constable approached another engraver, William Ward, in 1828, when he asked for an estimate for making a plate of *Hampstead Heath*.[16]

Throughout their relationship, which had to withstand many severe trials, Constable maintained a gentle affection for Lucas that bespeaks considerable sympathy between the two men. He had often to berate Lucas for his unreliability and slovenliness, and their correspondence sometimes gives the impression that a serious flaw in the whole project was the incompatibility of Constable's perfectionism with Lucas's more mediocre genius. 'I am so sadly grieved', Constable had to write in February 1832, 'at the proof you now send me of the Castle ['Hadleigh Castle'] that I am most anxious to see you. Your art may have resources of which I know nothing–but so deplorably deficient in all feeling is the present state of the plate that I can suggest nothing at all–to me it is *utterly–, utterly* HOPELESS'.[17] In passages like this Constable seems goaded to despair by Lucas's failure to measure up to his high demands. The sense of disparity comes across even more clearly in a letter of about December 1834: 'We have all our foibles and our failings a love of money has seemed always to me to be yours–take care lest it lead you to abandon that independency of spirit–those habits of pains taking–to which I once so much delighted to administer all the encouragement in my power, in all ways [.] this made you an artist . . . I now offer this (perhaps) my last advice–that you study to preserve this moral feeling in Art–it can have no better name–'.[18]

To Constable's attacks, Lucas replied with the humility of the student reproved by his master–that relationship is strongly present in their connection–but also with some indignation: 'you have many times laid things to my charge which I am not conscious of deserving [.] I do not mean to say I have always acted right but if all you say of me is true I should think myself unworthy of your regard [;] you seem to think I stick at nothing where my own interest is concerned, but I have made not a few sacrifices rather than act in a way that I anticipated would be disagreable [*sic*] to you'.[19] In spite of these quarrels, Constable seems to have had a real esteem for Lucas. He encouraged him to try for election as Associate of the Royal Academy in 1835;[20] and in September of the same year spoke very much as an equal and sympathiser when he said, in a letter: 'both you and me

ought to guard ourselves against our own enthusiasm. – though we are indebted to it for everything –';[21] which suggests that he found Lucas an essentially congenial spirit. 'We have a bond of friendship,' he wrote on another occasion, summing up their joint achievement, '. . . in the lovely amalgamation of our works.'[22]

Lucas had begun work on the *English Landscape Scenery* plates by mid-September 1829. Constable paid him £15 per plate. By the time that the first number appeared in June 1830, considerably more plates had been finished (or begun) than the four in that issue. Constable planned to print the plates on India paper (issued in dark pink paper covers), French paper (in purple covers) and English (in blue covers); three other issues followed, each with four plates, and a fifth appeared in about July 1832, with four plates plus a frontispiece and a vignette. Constable referred several times in his letters to a sixth number or 'Appendix' which was to have contained some of the plates rejected from the earlier issues; but this did not appear. Instead a second, rearranged edition of the original set of plates was published in May 1833. It was in this edition that the term 'chiaroscuro' was used in the title, and Constable added several pages of notes on the plates.

Most of the unused plates were published after his death: six by the bookseller Moon in 1838, and fourteen by Lucas himself in 1845. The whole set was reprinted for Bohn in 1855, but by that date the plates had been heavily reworked, either at Constable's own insistence or to remedy the effects of wear, and had lost virtually all their quality. 186 sets of plates were used as illustrations to the first edition of C. R. Leslie's *Memoirs* of the life of Constable, 1843.

Constable's own temperament was largely responsible for the comparative rarity of good impressions of the *English Landscape* plates: throughout the work on the publication he continually changed his mind about details, revising compositions, altering effects and giving Lucas the almost impossible task of preserving the freshness of the mezzotint through countless reworkings. Lucas's own shortcomings increased the difficulties and delays that Constable's uncertainty created: plates were often reworked, or even re-started, because of Lucas's failure to do what was required of him.

The same vacillations characterised the genesis of the letterpress. Constable attached considerable importance to this, for he wished the final work to be a full explanation of, and apology for, his art. In the first edition, this purpose remained implicit; no letterpress appeared, except a short Introduction in which the expression of the phenomenon of the 'Chiar'oscuro in Nature' was referred to in passing. This Introduction was probably not written until the separate paper-bound issues of the first edition were almost all out – that is to say, until the spring of 1832. But for the second edition he went to some pains to present his ideas in verbal as well as pictorial form. In October 1832 he wrote: 'the letterpress ... would (if done my way) consist of descriptions – quotations – poetic display – and principles of art &c, &c – 10 or 20 lines to Each, and as much moral feeling as possible'.[23] The expanded title with its reference to 'chiaroscuro' is symptomatic of the new approach, which was apparent too in the various advertisements and prospectuses that Constable issued. These largely anticipated the remarks he made in his Introduction, where the emphasis is firmly laid on the 'Phaenomena of the Chiaro'Scuro of Nature' and the aim of the prints 'to direct attention' to these. Constable claimed that it was initially 'only a pleasing professional occupation, and was pursued with the hope of imparting pleasure and instruction to others'. In practice, it had already, by the time this Introduction was printed, developed into a labour that occasioned him great anguish.

A further declared aim was 'to increase the interest for, and promote the study of the Rural Scenery of England'. Constable's explanatory texts contain, in addition to their rhapsodic descriptions, historical and other facts intended to enhance this more practical and 'scientific' aspect of the work. In his desire to present a survey of particular topographical, climatic or historic features, he brings his publication close to another area of contemporary art publishing: that of the album of engraved picturesque views. These had been common since about 1790, but had reached a peak of popularity in the 1820s, when finely engraved plates were issued in good bindings with texts that often provided a mass of geographical and historical information about the places depicted. Constable's comments on the wool industry, à propos of the plate of 'Stoke by Neyland', or on the ancient political importance of Old Sarum, belong very much to this category.

Perhaps the finest, though not the most successful, of such works was Charles Heath's *Picturesque Views in England and Wales*, for which Turner made nearly a hundred watercolours, and which began to appear in 1827, shortly before the inception of *English Landscape Scenery*. An even more obvious precursor is Turner's series of *The Rivers of England*, which appeared between 1823 and 1827. This was again a sequence of 'picturesque views', but executed in mezzotint, like the *Liber Studiorum*, and on a small scale rather similar to that of Constable's work. Some of Turner's plates are, as we should expect, of the type which Constable would have classified as 'grand': the 'Warkworth Castle' and 'Arundel Mill with a Rainbow'[24] correspond to subjects like 'Hadleigh Castle', 'Weymouth Bay' or 'Old Sarum' in the *English Landscape Scenery*. But several are of a more relaxed, pastoral type not far removed from the spirit of Constable's most characteristic work: the view of 'More Park',[25] for example, has an effect of shifting light and sparkling verdure akin to that of, say, 'A Summerland'. Turner is, as always, more formal in his approach both to composition and technique, and the neat, precise watercolours that he provided for the engravers inspired mezzotints of a character radically different from those Lucas made in imitation of Constable's exhilaratingly free oil sketches. Indeed, whereas Turner's engravers worked from models roughly the size of their plates, Lucas was often asked to reproduce a much larger image, even sometimes a full-scale picture such as the *White Horse* or the *Lock on the Stour*.

In the case of the *Liber Studiorum*, Turner made uniform sepia drawings of all the subjects he selected for engraving, regardless of whether the original was oil painting, watercolour or monochrome sketch. Constable made no such provision for Lucas. It is true that, in general, the originals he chose were not very much larger than the plates: oil sketches on small panels or on millboard, made at various times during the previous thirty years. These are of a remarkable technical consistency, and, though they represent a wide span of Constable's career, show him only in one aspect, as he worked on a small scale, mostly direct from nature. If Constable really wished to give, as Turner had done, a comprehensive picture of his achievement, he was bound to include some of his larger, finished works. Accordingly, Lucas engraved, in addition to the two large pictures just mentioned, the *Dell, Helmingham Park* of about 1825 – Constable said the print was 'taken light and shadow from that picture', *Weymouth Bay*, of about 1819, *Summerland – Ploughing in Suffolk* of 1814, the large *River Stour* of 1822, *Hadleigh Castle* of 1829; and several others, including, as one of the additional plates, *Arundel Mill and Castle*, which was not exhibited until 1837 after Constable's death. This composition also exists in the form of a small, informal oil study on panel (now in the De Young Museum, San Francisco),[26] and it

would be reasonable to suppose that Lucas would have used that as the original from which he worked; the problems of reducing detail from a very large to a very small format would then have been avoided. It is evident, however, that he did not do so. His plate is a virtuoso rendering of the minutiae of Constable's late style, with careful attention to the treatment of foreground detail in scumbled impasto so characteristic of the late paintings. In the execution of some plates, such as 'Arundel', 'Gillingham Mill', or 'Cottage in a Cornfield', this refinement and delicacy of touch are particularly apparent.

Often in working from the smaller sketches, Lucas encountered difficulties in the translation of Constable's vigorous brushwork into mezzotint. It is one of the peculiar virtues of mezzotint that it can render effects of loaded paint with great accuracy; but it seems that the more free and generalised Constable's use of paint, that is, the greater his dependence on the paint itself to convey his meaning, and the larger the relative scale of the paint-strokes to the painted area, the more difficult Lucas's job of translation became. Instead of finding the masses of small-scale detail in the large finished canvases hard to render, he was given great trouble by the less specific and circumstantial handling of the smaller studies. It was usually these, it seems, that caused him to present Constable with proofs that, like the first 'Glebe Farm' plate, were characterised by 'a total absence of breadth, richness, tone, chiaroscuro – & substituting soot, black fog, smoke, crackle, prickly rubble, scratches, edginess, want of keeping, & an intolerable & restless irritation'.[27] That is a forcible expression of Constable's sense of the gap in interpretation between his brushwork and Lucas's engraving. It is therefore a measure not only of Lucas's perseverance but of his greatness as an interpretative engraver that, in the end, in their finest impressions, his plates are almost all remarkably faithful translations of Constable's intentions – 'the lovely amalgamation' of their works that the artist found so satisfactory.

Notes to the text

1 See Leslie, p.114

2 Leslie, p.280.

3 See William Blake, *Complete Writings*, ed. Sir Geoffrey Keynes, revised paperback edition 1971, p.569.

4 Leslie, p.315.

5 Leslie, p.316.

6 Leslie, pp.316–17.

7 See A. J. Finberg, *The History of Turner's Liber Studiorum*, 1924.

8 For Constable and Arnald, see R. B. Beckett, *Constable's Correspondence*, IV, 1966, pp.258–261.

9 Shirley, p.47.

10 For examples of Constable's experiments with layout and classification see Beckett, pp.444–449.

11 Leslie, p.297.

12 See Leslie, pp.141–2.

13 Leslie, p.135.

14 See Charles Holmes, *Constable and his influence on Landscape Painting*, 1902, p.134: '. . . his art was based upon Chiaroscuro, upon a very definite arrangement of light and shade. His sketches, with all their vividness and freshness of colour, are really constructed on a monochrome foundation, so that they retain their unity of composition when the colour is taken away'.

15 For a brief survey of Lucas's life and work see Shirley, pp.10–14, and Beckett, pp.314ff.

16 Beckett, pp.311. The enquiry occurs in a letter dated 10 March 1828.

17 Letter of 5 February 1832; Shirley, letter no.88, p.70.

18 Shirley, letter no. 159, p.118.

19 Letter of 14 December 1834; Shirley, letter no.160, p.119.

20 See, e.g., letter of 6 September 1835, Shirley letter no.169, pp.126–7.

21 Shirley, letter no.170, p.128.

22 Shirley, letter no.161, p.121.

23 Letter of 7 October 1822, Shirley, letter no.120, pp.90–1.

24 W. G. Rawlinson, *The Engraved Work of J. M. W. Turner, R. A.*, 2 vols, 1908 and 1913; vol.1, nos.762,768.

25 Rawlinson, no.754.

26 The oil sketch of *Arundel Mill and Castle* has a label on the back of the panel saying that it was the property of George Constable of Arundel, for whom the large picture was painted.

27 Letter of November 1831, Shirley, letter no.79, p.65.

Note on the plates

With the exception of the Frontispiece and Vignette, the plates are listed in the order in which they appear in the set of paper-cover issues of the 1830–32 edition presented by Constable to Peter de Wint, and given to the British Museum by Miss Tatlock in May 1913. Those that did not figure in Constable's editions are in the order of Lucas's advertisement for the 1845 reprints, which includes five 'Rare Unpublished Plates' (nos.38–42). Where Constable composed letterpress for the 1833 edition, one of his many versions is reprinted with the relevant plate. In general, the plates that appeared in Constable's publication are reproduced from the de Wint set (BM 1913–5–24–326). These are all on india paper except those in the first issue (nos.3–6), which are on English wove paper. Where superior impressions of published plates exist in the Museum's collections, however, these have been used in preference to those from the bound set; their register numbers are given in the relevant captions, as are the register numbers of the unpublished plates. Where possible, the symbol denoting the 'class' of landscape represented by each subject, as it was assigned by Constable in his notes, is recorded here; not because it was used in publication, or indeed rigidly adhered to by the artist, but simply as a point of interest. See the introduction for comments on his system of classification. Since Constable altered the titles of the plates several times, his alternatives are given when they throw further light on the subject-matter.

The plates are reproduced at actual size except where indicated.

Biography

1776 Born 11 June, the son of Golding Constable, a well-to-do miller of East Bergholt, Suffolk.

1793 Sketching in Suffolk with a friend, the amateur artist John Dunthorne.

1795 Met the amateur and collector Sir George Beaumont, among whose pictures Constable admired works by Claude Lorrain (1600–82) and Thomas Girtin (1775–1802).

1796 Employed by the antiquarian draughtsman John Thomas Smith (1766–1833) to draw cottages in Suffolk.

1797 Visited Smith in London.

1799 Moved to London, with an introduction to Joseph Farington (1747–1821), an influential member of the Royal Academy. In March became a probationer at the Royal Academy Schools, where his studentship was confirmed in the following year. Copying from the Old Masters, and from Thomas Gainsborough (1727–88) and Richard Wilson (1714–82).

1801 In August made a tour of Derbyshire, sketching in pencil, pen and ink.

1802 His work shown for the first time at the annual exhibition of the Royal Academy.

1804 Working as a portrait painter, producing likenesses of Suffolk farmers and their families, at two or three guineas each.

1805 Commissioned to paint an altarpiece for a country church.

1806 In September and October toured the Lake District, making watercolour drawings and oil studies.

1809 Beginning of Constable's love-affair with Maria Bicknell.

1810 Painted an altarpiece, *Christ blessing the Bread and Wine*, for Neyland church.

1811 *Dedham Vale* exhibited at the R.A. Visited Salisbury, staying with Bishop Fisher; became friendly with the Bishop's nephew, John Fisher.

1813 *Landscape: Boys fishing (Lock on the Stour)* probably exhibited this year.

1814 *Landscape: Ploughing in Suffolk (A Summerland)* exhibited this year. Visit to Hadleigh Castle. Failure of the first of several attempts to gain election as Associate of the Royal Academy (A.R.A.).

1815 Death of Constable's mother.

1816 Death of Constable's father. 2 October: marriage to Maria Bicknell. The honeymoon spent at Osmington, Dorset.

1817 *Scene on a navigable river (Flatford Mill)* exhibited. On 4 December the birth of a son, Charles, the first of seven children.

1818 Elected a Director of the Artists' General Benevolent Institution.

1819 *The White Horse* exhibited; it was well received, and sold to John Fisher for 100 guineas. Constable rented a cottage near Hampstead Heath for the summer; his family were to return to Hampstead frequently in future years. In November, elected A.R.A.

1820 *Stratford Mill* exhibited.

1821 *The Hay Wain* exhibited.

1822 *View on the Stour* exhibited. Constable moved into 35 Charlotte Street, Fitzroy Square, where he was to retain a studio for the rest of his life.

1823 *Salisbury Cathedral from the Bishop's grounds* exhibited. Visit to Gillingham with John Fisher in August; in October, stayed with Sir George Beaumont at Coleorton, Leicestershire.

1824 Pictures by Constable, including *The Hay Wain*, exhibited at the Paris Salon, where they gained him a Gold Medal. To Brighton in the summer, with his family, largely on account of his wife's poor health.

1825 *The Leaping Horse* exhibited. Three of his pictures shown among the 'Modern Masters' exhibited at the British Institution. At the Lille Salon, his paintings won a further Gold Medal. To Brighton in the summer. Beginning of a friendship with the artist C. R. Leslie (1794–1859), whom he had defeated as A.R.A. in 1819.

1826 *Landscape (the Cornfield)* exhibited. Leslie elected R.A.

1827 *Gillingham Mill* exhibited, together with the large *Chain Pier, Brighton*. Acquired a house in Well Walk, Hampstead.

1828 *Landscape (Branch Hill Pond, Hampstead)* and *Dedham Vale* exhibited. To Brighton; after the birth of her seventh child, Lionel Bicknell, Maria remained unwell, and rapidly succumbed to tuberculosis. She died on 23 November.

1829 Elected R.A. in February. *Hadleigh Castle* exhibited. Work begun on *English Landscape Scenery*.

1830 *Helmingham Dell* exhibited. The first two numbers of *English Landscape Scenery* published.

1831 Preoccupied with work on *English Landscape Scenery*. *Salisbury Cathedral from the Meadows* exhibited.

1832 *Whitehall Stairs 9 June 1817 (the Opening of Waterloo Bridge)* and *Jacques and the wounded Stag* exhibited. The beginning of Constable's friendship with George Constable of Arundel.

1833 A new, cheaper edition of *English Landscape Scenery* published, with altered title and text. June: lectured on Landscape to the Hampstead Literary and Scientific Society.

1834 Constable ill with rheumatic fever. *The mound of the city of Old Sarum, from the south* (watercolour) exhibited.

1835 *The Glebe Farm* exhibited.

1836 Lectures on landscape delivered at the Royal Institution.

1837 31 March: death of Constable. *Arundel Mill and Castle* exhibited posthumously at the R.A.

Bibliography

The initial letters preceding four of these entries are the abbreviations used here in referring to catalogues of Lucas's prints or Constable's original designs:

C. R. Leslie, *Memoirs of the Life of John Constable composed chiefly of his Letters*, 1843; edited and annotated by Jonathan Mayne, 1951

W Frederick Wedmore, *Constable: Lucas: With a descriptive Catalogue of the Prints they did between them*, 1914

S Hon. Andrew Shirley, *The Published Mezzotints of David Lucas after John Constable*, 1930

R Graham Reynolds, *Catalogue of the Constable Collection in the Victoria and Albert Museum*, 1960

Graham Reynolds, *Constable, the Natural Painter*, 1965

R. B. Beckett, *John Constable's Correspondence*, vol. IV, 1966, pp. 314–443.

T Tate Gallery, *Constable*, Bicentenary Exhibition Catalogue by Leslie Parris and Ian Fleming-Williams, 1976

Reg Gadney, *John Constable, R.A. 1776–1837. A Catalogue of Drawings and Watercolours, with a selection of Mezzotints by David Lucas, after Constable for 'English Landscape Scenery', in the Fitzwilliam Museum, Cambridge*, 1976

'English Landscape Scenery'

VARIOUS SUBJECTS OF

LANDSCAPE,

CHARACTERISTIC OF ENGLISH SCENERY,

FROM PICTURES PAINTED BY

JOHN CONSTABLE, R. A.

ENGRAVED BY

DAVID LUCAS.

London:

PUBLISHED BY MR. CONSTABLE, 35, CHARLOTTE STREET, FITZROY SQUARE.

SOLD BY COLNAGHI, DOMINIC COLNAGHI, AND CO. PALL MALL EAST.

1830.

Title page of 1830 edition

VARIOUS SUBJECTS OF

LANDSCAPE,

CHARACTERISTIC OF ENGLISH SCENERY,

PRINCIPALLY INTENDED TO MARK

THE PHENOMENA OF THE CHIAR'OSCURO OF NATURE:

FROM PICTURES PAINTED BY

JOHN CONSTABLE, R. A.

ENGRAVED BY

DAVID LUCAS.

London:

PUBLISHED BY MR. CONSTABLE, 35, CHARLOTTE STREET, FITZROY SQUARE.

SOLD BY COLNAGHI, DOMINIC COLNAGHI, AND CO. PALL MALL EAST

1833.

Title page of 1833 edition

English Landscape.

"OH, NATURE! all sufficient! over all!
Enrich me with the knowledge of thy works!
Snatch me to heaven; thy rolling wonders there,
World beyond world, in infinite extent,
Profusely scatter'd o'er the blue immense,
Shew me; their motions, periods, and their laws,
Give me to scan; through the disclosing deep
Light my blind way; the mineral strata there;
Thrust, blooming, thence the vegetable world;
O'er that the rising system, more complex,
Of animals; and higher still, the mind,
The varied scene of quick-compounded thought,
But if to that unequal; if the blood,
In sluggish streams about my heart, forbid
That best ambition;—UNDER CLOSING SHADES,
INGLORIOUS, LAY ME BY THE LOWLY BROOK,
AND WHISPER TO MY DREAMS." ——*Thomson.*

First set of verses, from 1833 edition

22

English Landscape.

"O England! dearer far than life is dear,
 If I forget thy prowess, never more
Be thy ungrateful son allowed to heer
Thy green leaves rustle, or thy torrents roar!"—
 WORDSWORTH.

*Rura mihi, et rigui placeant in vallibus amnes,
 Flumina amem, sylvasque, inglorius.*
 VIRGIL.

Respiciens rura, laremque suum.
 OVID.

Alternative verses, from 1833 edition

23

INTRODUCTION.

THE Author rests in the belief that the present collection of Prints of Rural Landscape may not be found wholly unworthy of attention. It originated in no mercenary views, but merely as a pleasing professional occupation, and was continued with a hope of imparting pleasure and instruction to others. He had imagined to himself an object in art, and has always pursued it. Much of the Landscape, forming the subject of these Plates, going far to embody his ideas (owing perhaps to the rich and feeling manner in which they are engraved) he has been tempted to publish them, and offers them as the result of his own experience, founded as he conceives it to be in a just observation of natural scenery in its various aspects. From the almost universal esteem in which the Arts are now held, the Author is encouraged to hope that this work may not be found unacceptable, since perhaps no branch of the Art offers a more inviting field of study than Landscape.

The immediate aim of the Author in this publication is to increase the interest for, and promote the study of, the Rural Scenery of England, with all its endearing associations, its amenities, and even in its most simple localities; abounding as it does in grandeur, and every description of Pastoral Beauty: England, with her climate of more than vernal freshness, and in whose summer skies, and rich autumnal clouds, the observer of Nature may daily watch her endless varieties of effect.

But perhaps it is in its professional character that this work may be most considered, so far as it respects the ART; its aim being to direct attention to the source of one of its most efficient principles, the " CHIAROSCURO OF NATURE," to mark the influence of light and shadow upon Landscape, not only in its general impression, and as a means of rendering a proper emphasis on the parts, but also to show its use and power as a medium of expression, so as to note " the day, the hour, the sunshine, and the shade." In some of these subjects of Landscape an attempt has been made to arrest the more abrupt and transient appearances of the CHIAROSCURO IN NATURE; to shew its effect in the most striking manner, to give " to one brief moment caught from fleeting time," a lasting and sober existence, and to render permanent many of those splendid but evanescent Exhibitions, which are ever occurring in the endless varieties of Nature, in her external changes.

The effects of light and shadow selected for these views, are transcripts only of such as occurred at the time of their being taken. The subjects, consisting mostly of home scenery, are taken from real places; and are meant particularly to characterize the scenery of England: in their selection a partiality has certainly been given to those of a particular neighbourhood. Some of them, however, may be more generally interesting, as the scenes of many of the marked historical events of our middle ages.

In Art as in Literature, there are two modes by which men endeavour to attain the same end, and seek distinction. In the one, the Artist, intent only on the study of departed excellence, or on what others have accomplished, becomes an imitator of their works, or he selects and combines their various beauties; in the other he seeks perfection at its PRIMITIVE SOURCE, NATURE. The one, forms a style upon the study of pictures, or the art alone; and produces, either " imitative," " scholastic," or that which has been termed " Eclectic Art." The other, by study equally legitimately founded in art, but further pursued in such a far more expansive field, soon finds for himself innumerable sources of study, hitherto unexplored, fertile in beauty, and by attempting to display them for the first time, forms a style which is original; thus adding to the Art, qualities of Nature unknown to it before. The results of the one mode, as they merely repeat what has been done by others, and by having the appearance of that with which the eye is already familiar, can be easily comprehended, soon estimated, and are at once received. Thus the rise of an Artist in a sphere of his own must almost certainly be delayed; it is time generally that the justness of his claims to a lasting reputation will be left; so few appreciate any deviation from a beaten track, can trace the indications of Talent in immaturity, or are qualified to judge of productions bearing an original cast of mind, of genuine study, and of consequent novelty of style in their mode of execution.

35, CHARLOTTE STREET, FITZROY SQUARE,
January, 1833.

Introduction to 1833 edition

LIST OF THE ENGRAVINGS

Of Mr. Constable's English Landscape,

WITH THEIR ARRANGEMENT.

Frontispiece—House of the late
Golding Constable, Esq. and Birth Place of the Artist.

Spring. East Bergholt Common.
Sunset. Peasants returning homeward.

Noon. West End Fields, Hampstead.
Scene on the River Stour, Suffolk.

Summer Morning. The Home-field. Dedham.
Summer Evening. Cattle reposing. East Bergholt.

Dell in Helmingham Park, Suffolk.
Hampstead Heath. Stormy noon.

Yarmouth Pier, Norfolk. Morning.
Sea-beach, Brighton. Brisk wind.

River Stour, near Flatford Mill.
Head of a Lock, on the Stour.

Mound of the City of Old Sarum.
Summerland. Rainy Day. The Ploughman.

Stoke Church, near Neyland, Suffolk.
An Undershot-Mill, Dedham, Essex.

Weymouth Bay, Dorset. Tempestuous Evening.
Summer Afternoon. Sunshine after a Shower.

The Glebe Farm and Green Lane. Girl at the Spring.
The Nore, Hadleigh Castle, Mouth of the Thames.

Vignette, Hampstead Heath.

List of engravings, from 1833 edition

Plate 1 *Frontispiece – East Bergholt, Suffolk*
First issued in part five, 1831

Alternative titles
House and Grounds of the late Golding
Constable, Esq. East Bergholt, Suffolk;
House of the late Golding Constable, Esq. and
Birth Place of the Artist.
Original untraced
Bibliography W 1; S 27

EAST BERGHOLT, SUFFOLK
House and Grounds of the late Golding
Constable, Esq.

'*Respiciens rura, laremque suam.*'

'With frequent foot
Pleased have I in my cheerful morn of life,
When nursed by careless solitude I lived
And sung of Nature with unceasing joy,
Pleased have I wandered o'er your fair domain.'

As this work was begun and pursued by the Author solely
with a view of his own feelings, as well as his own notions
of Art, he may be pardoned for introducing a spot to which
he must naturally feel so much attached; and though to
others it may be void of interest or any associations, to him
it is fraught with every endearing recollection.

In this plate the endeavour has been to give, by richness
of Light and Shadow, an interest to a subject otherwise by
no means attractive. The broad still lights of a Summer
evening, with the solemn and far-extended shadows cast
around by the intervening objects, small portions of them
only and of the Landscape gilded by the setting sun, cannot
fail to give an interest to the most simple or barren subject,
and even to mark it with pathos and effect.

East Bergholt, or as its Saxon derivation implies,
'Wooded Hill,' is thus mentioned in 'The Beauties of
England and Wales':– 'South of the church is "Old Hall,"
the Manor House, the seat of Peter Godfrey, Esq., which,
with the residences of the rector, the Reverend Dr. Rhudde,
Mrs. Roberts, and Golding Constable, Esq., give this place
an appearance far superior to that of most villages.' It is
pleasantly situated in the most cultivated part of Suffolk, on
a spot which overlooks the fertile valley of the Stour, which
river divides that county on the south from Essex. The
beauty of the surrounding scenery, the gentle declivities,
the luxuriant meadow flats sprinkled with flocks and herds,
and well cultivated uplands, the woods and rivers, the
numerous scattered villages and churches, with farms and
picturesque cottages, all impart to this particular spot an
amenity and elegance hardly anywhere else to be found; and
which has always caused it to be admired by all persons of
taste, who have been lovers of Painting, and who can feel a
pleasure in its pursuit when united with the contemplation
of Nature.*

Perhaps the Author with an over-weening affection for
these scenes may estimate them too highly, and may have
dwelt too exclusively upon them; but interwoven as they
are with his thoughts, it would have been difficult to have
avoided doing so; besides, every recollection associated
with the Vale of Dedham must always be dear to him, and
he delights to retrace those scenes, 'where once his careless
childhood strayed,' among which the happy years of the
morning of his life were passed, and where by a fortunate
chance of events he early met those, by whose valuable and
encouraging friendship he was invited to pursue his first
youthful wish, and to realize his cherished hopes, and that
ultimately led to fix him in that pursuit to which he felt his
mind directed: and where is the student of Landscape, who
in the ardour of youth, would not willingly forego the
vainer pleasures of society, and seek his reward in the
delights resulting from the love and study of Nature, and in
his successful attempts to imitate her in the features of the
scenery with which he is surrounded; so that in whatever
spot he may be placed, he shall be impressed with the
beauty and majesty of Nature under all her appearances,
and, thus, be led to adore the hand that has, with such lavish
beneficence, scattered the principles of enjoyment and
happiness throughout every department of the Creation. It
was in scenes such as these, and he trusts with such a
feeling, that the Author's ideas of Landscape were formed;
and he dwells on the retrospect of those happy days and
years 'of sweet retired solitude,' passed in the calm of an
undisturbed congenial study, with a fondness and delight
which must ever be to him a source of happiness and
contentment.

'Nature! enchanting Nature! in whose form
And lineaments divine I trace a hand
That errs not, and find raptures still renew'd,
Is free to all men – universal prize.'

*The late Dr. John Fisher, Bishop of Exeter, and afterwards
Bishop of Salisbury, and also the late Sir George Beaumont,
Baronet, both well known as admirers and patrons of Painting,
often passed their summers at Dedham, the adjoining village to
Bergholt; to the latter of whom the Author was happily introduced
through the anxious and parental attention of his Mother; and for
his truly valuable acquaintance with Dr. Fisher, he was indebted to
the kindness of his early friends, the Hurlocks – of which circum-
stance he has a lively and grateful remembrance. These events
entirely influenced his future life, and were the foundation of a
sincere and uninterrupted friendship, which terminated but with
the lives of these estimable men.

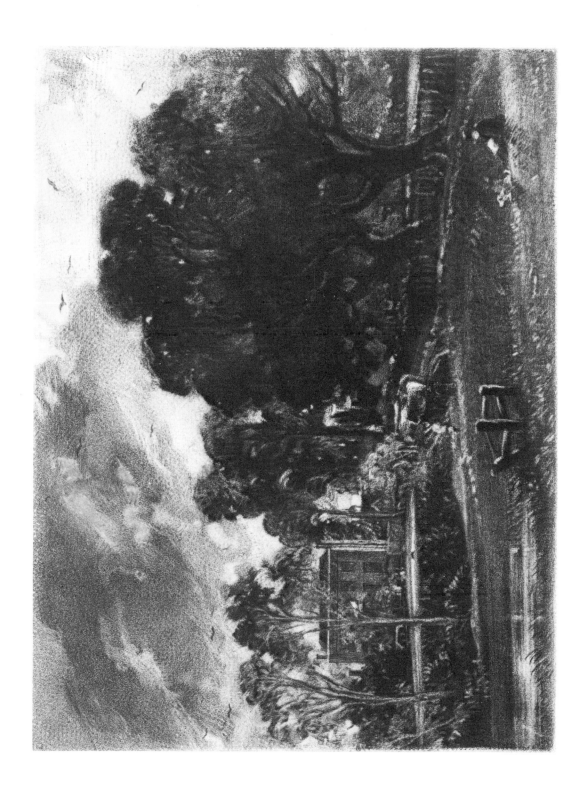

Plate 2 *Vignette – Hampstead Heath, Middlesex*
First issued in part five, 1831

Original untraced
Bibliography W 22; S 3

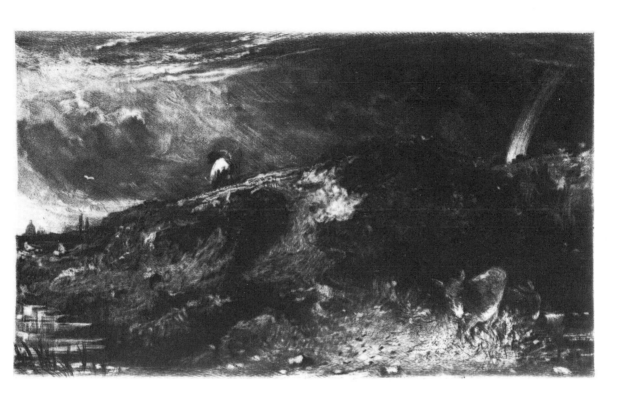

Plate 3 *A Mill*
First issued in part one, 1830

Alternative titles
A Water-Mill, Dedham, Essex;
An Undershot-Mill, Dedham, Essex.

Symbol p

Original untraced. Leslie says the print
was made 'from a slight sketch'.

Bibliography W 17; S 5

Slightly reduced

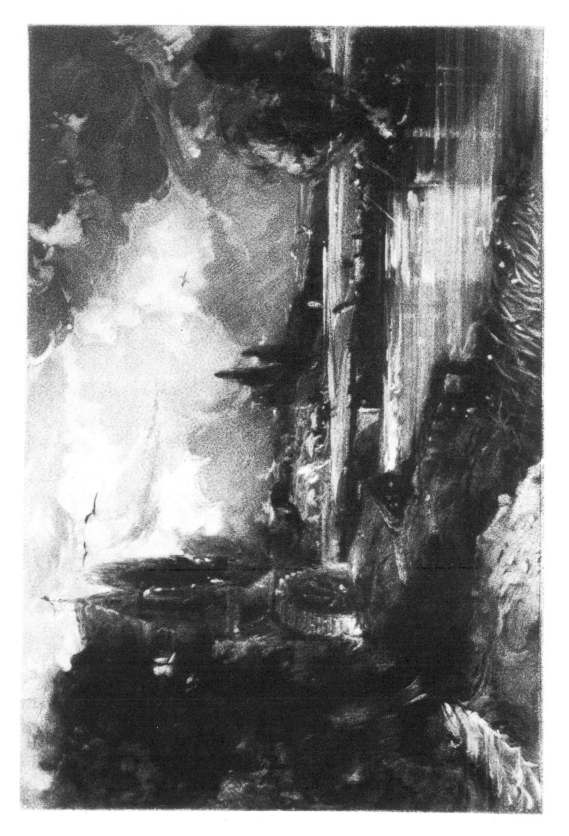

Plate 4 *Spring*

First issued in part one, 1830.

Alternative titles

Spring. A Mill on a Common. Hail Squalls;
Spring. East Bergholt Common.

Symbol p

Original oil sketch on panel of ?1816. V&A
(R 122)

Bibliography W 2; S 7

Slightly reduced

SPRING

'Hence the breath
Of life informing each organic frame;
Hence the green earth, and wild resounding waves;
Hence light and shade alternate, warmth and cold,
And bright and dewy clouds, and vernal show'rs,
And all the fair variety of things.'

This plate may perhaps give some idea of one of those bright and animated days of the early year, when all nature bears so exhilarating an aspect; when at noon large garish clouds, surcharged with hail or sleet, sweep with their broad cool shadows the fields, woods, and hills; and by the contrast of their depths and bloom enhance the value of the vivid greens and yellows, so peculiar to this season; heightening also their brightness, and by their motion causing that playful change, always so much desired by the painter.

The natural history – if the expression may be used – of the skies above alluded to, which are so particularly marked in the hail squalls at this time of the year, is this: – the clouds accumulate in very large and dense masses, and from their loftiness seem to move but slowly: immediately upon these large clouds appear numerous opaque patches, which, however, are only small clouds passing rapidly before them, and consisting of isolated pieces, detached probably from the larger cloud. These floating much nearer the earth, may perhaps fall in with a stronger current of wind, which as well as their comparative lightness, causes them to move with greater rapidity; hence they are called by wind-millers and sailors 'messengers,' being always the forerunners of bad weather. They float about midway in what may be termed the *lanes* of the clouds; and from being so situated, are almost uniformly in shadow, receiving only a reflected light from the clear blue sky immediately above, and which descends perpendicularly upon them into these *lanes*. In passing over the bright parts of the large clouds, they appear as 'darks'; but in passing the shadowed parts they assume a gray, a pale, or lurid hue.

'Fair-handed Spring unbosoms every grace.'

The Autumn only is called the painter's season, from the great richness of the colours of the *dead* and decaying foliage, and the peculiar tone and beauty of the skies; but the Spring has perhaps more than an equal claim to his notice and admiration, and from causes not wholly dissimilar – the great variety of tints and colours of the *living* foliage, besides having the flowers and blossoms. The beautiful and tender hues of the young leaves and buds are rendered more lovely by being contrasted, as they now are, with the sober russet browns of the trees and hedges from which they shoot, and which still shew the drear remains of the season that is past. The tender beauties which wait upon this flowery season are but too often premature; the early blights and 'killing frosts' which usually attend it have caused the fickleness of Spring to be proverbial, even with the poets, who feelingly allude to it – 'Abortive as the first-born bloom of spring:' – their genius, however, has made it a source of the most beautiful and touching imagery.

'Hoary-headed frosts
Fall in the fresh lap of the crimson rose;
And on old Hyems' chin and icy crown
An od'rous chaplet of sweet summer buds
Is as in mockery set.'

The ploughman 'leaning o'er the shining share,' the sower 'stalking with measured step the neighbouring fields,' are conspicuous objects in the vernal landscape; and last, though not least in interest, the birds, 'by the great Father of the Spring inspired,' who with their songs again cheer the labourer at his work, and complete the joyous animation of the new season.

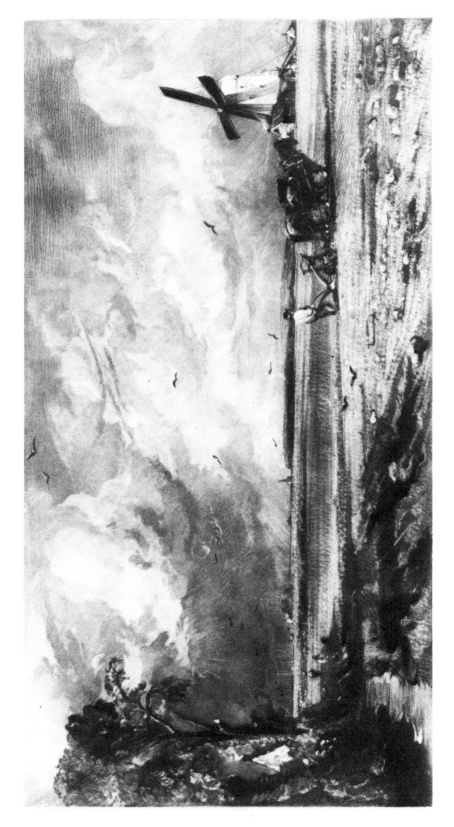

Plate 5 *A Dell, Helmingham Park, Suffolk*

First issued in part one, 1830
1842-12-10-78

Alternative titles
Dell in the Woods of Helmingham
Park, Suffolk;
Dell in Helmingham Park, Suffolk.

Symbol pf

Original drawing of *c.*1800, UK private
collection (T 12) and painting of
1825–6, John G. Johnson collection,
Philadelphia (T 295).

Bibliography W 9; S 12

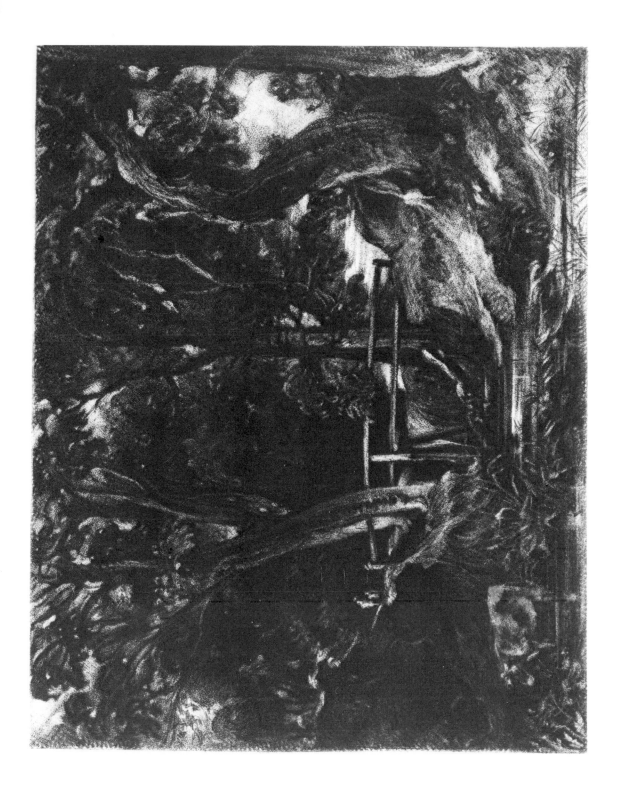

Plate 6 *Weymouth Bay, Dorsetshire*
First issued in part one, 1830

Alternative titles
Weymouth Bay, Dorset.
Tempestuous Afternoon;
Weymouth Bay, Dorset.
Tempestuous Evening.

Symbol g

Original painting of *c*.1819 in the
Louvre, no.1808; see also V & A
(R155).

Bibliography W18; S13

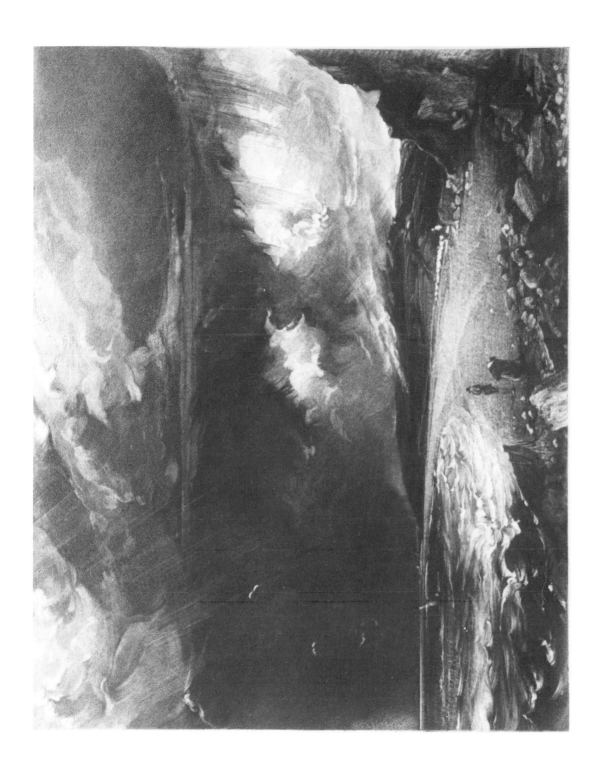

Plate 7 *Stoke by Neyland, Suffolk*
First issued in part two, 1830
1842-12-10-139

Alternative title
Stoke Church, near Neyland, Suffolk.

Symbol pf

Original oil study on paper, V & A (R 330);
see also Tate Gallery, no.1819.

Bibliography W 16; S 9

Slightly reduced

STOKE by NEYLAND, SUFFOLK

'Through the lighten'd air
A higher lustre and a clearer calm
Diffusive tremble.'

The solemn stillness of Nature in a Summer's Noon, when attended by thunder-clouds, is the sentiment attempted in this print; at the same time an endeavour has been made to give an additional interest to this Landscape by the introduction of the Rainbow, and other attending circumstances that might occur at such an hour. The effect of light and shadow on the sky and landscape are such as would be observed when looking to the northward at noon; that time of day being decidedly marked by the direction of the shadows and the sun shining full on the south side of the Church.

Of the Rainbow – the following observations can hardly fail to be useful to the Landscape Painter. When the Rainbow appears at Noon, the height of the sun at that hour of the day causes but a small segment of the circle to be seen, and this gives the Bow its low or flat appearance: the Noonday-bow is therefore best seen 'Smiling in a Winter's day,' as in the Summer, after the sun has passed a certain altitude, a Rainbow cannot appear: it must be observed that a Rainbow can never appear foreshortened, or be seen obliquely, as it must be parallel with the plane of the picture, though a part of it only may be introduced; nor can a Rainbow be seen through any intervening cloud, however small or thin, as the reflected rays are dispersed by it, and are thus prevented from reaching the eye; consequently the Bow is imperfect in that part. Nature, in all the varied aspects of her beauty, exhibits no feature more lovely nor any that awaken a more soothing reflection than the Rainbow, 'Mild arch of promise'; and when this phæno-menon appears under unusual circumstances it excites a more lively interest. This is the case with the 'Noon-tide Bow,' but more especially with that most beautiful and rare occurrence, the 'Lunar Bow.' The morning and evening Bows are more frequent than those at noon, and are far more imposing and attractive from their loftiness and span; the colours are also more brilliant, 'Flashing brief splendour through the clouds awhile.' For the same reason the exterior or secondary Bow is at these times also brighter, but the colours of it are reversed. A third, and even fourth

Bow, may sometimes be seen, with the colours alternating in each; these are always necessarily fainter, from the quantity of light lost at each reflection within the drop, according to the received principle of the Bow. Perhaps more remains yet to be discovered as to the cause of this most beautiful Phenomenon of Light, recent experiments having proved that the primitive colours are further refrangible. Though not generally observed, the space within the Bow is always lighter than the outer portion of the cloud on which it is seen. This circumstance has not escaped the notice of the Poet, who with that intuitive feeling which has so often anticipated the discoveries of the Philosopher, remarks:

'And all within the arch appeared to be
Brighter than that without.'

Suffolk, and many of the other eastern counties, abounds in noble Gothic Churches: the size of many of them, and seen as they now are standing in solitary and imposing grandeur in neglected and almost deserted spots, imparts a peculiar sentiment, and gives a solemn air to even the country itself, and they cannot fail to impress the mind of the stranger with the mingled emotions of melancholy and admiration. These magnificent structures are often found in scattered villages and sequestered places, out of the high roads, surrounded by a few poor dwellings, the remains only of former opulence and comfort; but ill according with such large and beautiful specimens of architecture. These spots were once the seats of the clothing manufactories, so long established in these counties, and which were so flourishing during the reigns of Henry VII. and VIII. being greatly increased by the continual arrival of the Flemings, bringing with them the bay trade, who found here a refuge from the cruel persecutions of their own Country, enjoying many privileges in return for their skill and industry; and also afterwards, when by a wise policy still greater encouragement was held out to them by Elizabeth, whom the course of events had raised to be the glory and support of Protestant Europe. The venerable grandeur of these religious edifices, with the charm that the mellowing hand of time hath cast over them, gives them an aspect of extreme solemnity and pathos; and they stand lasting and impressive monuments of the power and munificence of our Ecclesiastical Government. The church of Stoke, though by no means one of the largest, must be classed with these: it was probably erected about the fifteenth century; and there is reason to suppose that the same architect also built the two neighbouring churches, Lavenham and Dedham. The nave of Stoke church, with its long continued line of embattled parapet, the finely proportioned chancel, with the bold projection of the buttresses throughout the building, would be the admiration of the student, while its grandest feature the Tower, from its commanding height, seems to impress on the surrounding country its own sacred dignity of character.

In this Church are many interesting monuments, giving their frail memorial of departed worth and power: amongst them are several of the noble family of the Howards; one in

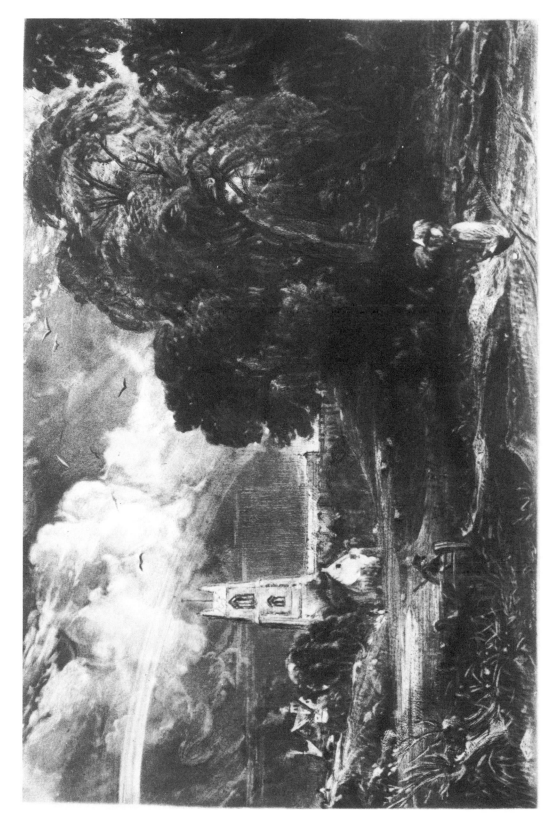

Plate 7 *continued*

Plate 8 *Noon*
First issued in part two, 1830

particular, in the south part between the high altar and the choir, where is interred, 'The Right Honourable Woman and Ladye, Catherine, some time Wife unto Iohn Duke of Norfolke,' who fell at the Battle of Bosworth Field. – She died A.D. 1452. Also one to Margaret, second wife of the same Duke. Here, as well as at Neyland, are many tombstones of the clothiers; being mostly laid on the pavement they are much worn and defaced, but are known to belong to them by peculiar small brasses in the form of a shield still remaining, on which are engraved the figure used by the defunct as 'The mark' by which his own manufactures were known, and usually here applied as supplying the place of armorial bearings.

Alternative titles
Noon. West End Fields, Hampstead; Summer Noon. The West End Fields, Hampstead.
Symbol p or LP
Original a painting formerly in the collection of Lady Binning.
Bibliography W 4; S 16
Slightly reduced

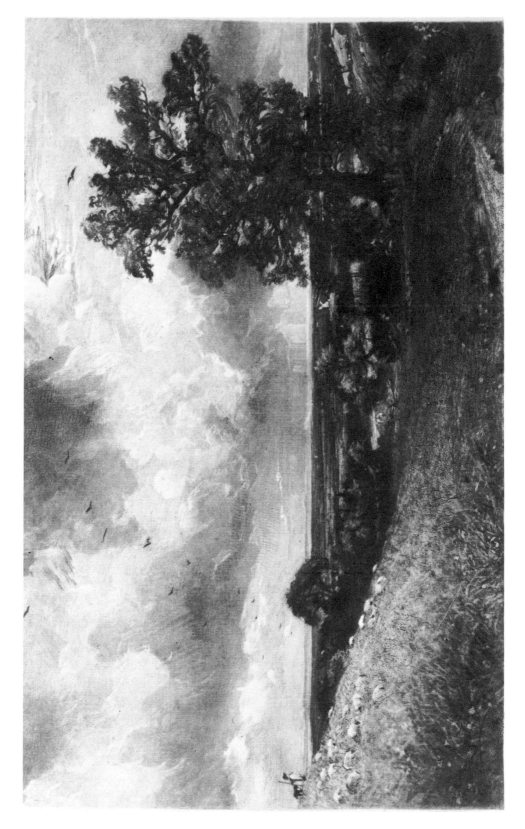

Plate 9 *A Sea Beach*
First issued in part two, 1830
1842-12-10-136

Alternative titles
Sea-Beach. Brighton. A Heavy Surf;
Sea-beach. Brighton. Brisk Wind.
Symbol L
Original oil sketch formerly in the collection of
George Salting.
Bibliography W 11; S 17
Slightly reduced

A SEA-BEACH-BRIGHTON

'But nearer land you may the billows trace,
As if contending in their watery chase;
Curl'd as they come they strike with furious force
And then re-flowing, take their grating course.'

The magnitude of a coming wave when viewed beneath the shelter of a Groyne – and which is the subject of the present plate – is most imposing; as, from being close under it, it seems overwhelming in its approach – at the same time, from its transparency, becoming illumined by the freshest and most beautiful colours. The structures termed Groynes, a kind of jetty, are numerous here; they are composed of timber in form and manner like a quay, but projecting into the seat at right angles with the shore. Groynes are admirable and indeed the only contrivances for preserving the beach and preventing the waves from reaching and undermining the cliffs: thus the shingle which on this coast is drifted from the West is arrested in its progress by them, and being so collected forms a beach which by its gradual slope and ample extent wards off the encroachments of the sea.

Of all the works of the Creation none is so imposing as the Ocean; nor does Nature anywhere present a scene that is more exhilarating than a sea-beach, or one so replete with interesting material to fill the canvass of the Painter; the continual change and ever-varying aspect of its surface always suggesting the most impressive and agreeable sentiments, – whether like the Poet he enjoys in solitude 'The wild music of the waves,' or when more actively engaged he exercises his pencil amongst the busy haunts of fishermen, or in the bustle and animation of the port or harbour.

It is intended in this print to give one of those animated days when the masses of clouds, agitated and torn, are passing rapidly; the wind at the same time meeting with a certain set of the tide, causes the sea to rise and swell with great animation; when perhaps a larger wave, easily distinguished by its scroll-like crest, may be seen running along over the rest coming rapidly forward; on nearing the shore it curls over, then in the elegant form of an alcove suddenly falling upon the beach, it spreads itself and retires. In such weather the voice of a solitary sea-fowl is heard from time to time 'Mingling its note with those of wind and wave'; when he may be observed beating his steady course for miles along the beach just above the breakers, and ready 'To drop for prey within the sweeping surge.' These birds, whether solitary or in flocks, add to the wildness and to the sentiment of melancholy always attendant on the ocean,

'While to the storm they give their weak complaining cry.'

Of Brighton and its Neighbourhood, now so well known, it is enough to say that there is perhaps no spot in Europe where so many circumstances conducive to health and enjoyment are to be found combined; and being situated as it is within so short a distance of the largest Metropolis in the world, will account at once for its extraordinary rise, its vast extent and population, and the almost countless numbers who visit it during the season: also from having so long enjoyed the sunshine of a Court, it has become an Emporium of fashion, under whose shadowy auspices thousands still resort to it; and thus connected as it is with the Metropolis, it has been aptly termed 'The marine side of London.'

It is therefore no longer a matter of surprise that a change otherwise so incredible should have taken place; and that a fishing town of so little importance, should in the space of a few years have become one of the largest, most splendid, and gayest places in the kingdom; the resort of multitudes of every class of society. To hint at some of the natural local causes which have secretly wrought this change, and of which the thousands who are annually benefited by them are so little aware, cannot be irrelevant here. The situation itself – the most favourable on the coast – is between two considerable rivers, the Adur and the Ouse, into which all the adjacent rivulets flow, rendering the inland country dry and healthful. The neighbouring hills keep off the severer winds, and leave it open to the more genial breezes of the West, which coming from the sea preserve an almost equal temperature. Nor is this the only advantage derived from the contiguity of the hills: their nature being calcarious, they absorb all superfluous moisture, producing at the same time springs of the very finest water, which flow spontaneously in many places. The beach, though rugged and unpleasant, has yet a healthful quality peculiar to itself, for where the stones end the chalk again appears, leaving a pure and wholesome shore.

Of the Climate, its salubrious qualities, though latent, are abundantly proved by the productions of the Vegetable Kingdom; since here may be found the Fig, the Almond, and the Myrtle perfecting their fruit in the open garden; and since the establishment of a Society for the encouragement of Horticulture, few places in the kingdom can vie with Brighton in the excellence and beauty of her fruits and flowers: 'the pink-eyed Pimpernel' here gives a silent but unerring testimony in favour of the climate, by its petals changing to a blue colour, a circumstance occurring only in the most mild and genial climates; and the remark that it is 'a country without trees, and a sea without ships,' will have little weight with those who have seen the flourishing condition of the trees and shrubs in the park, and even in

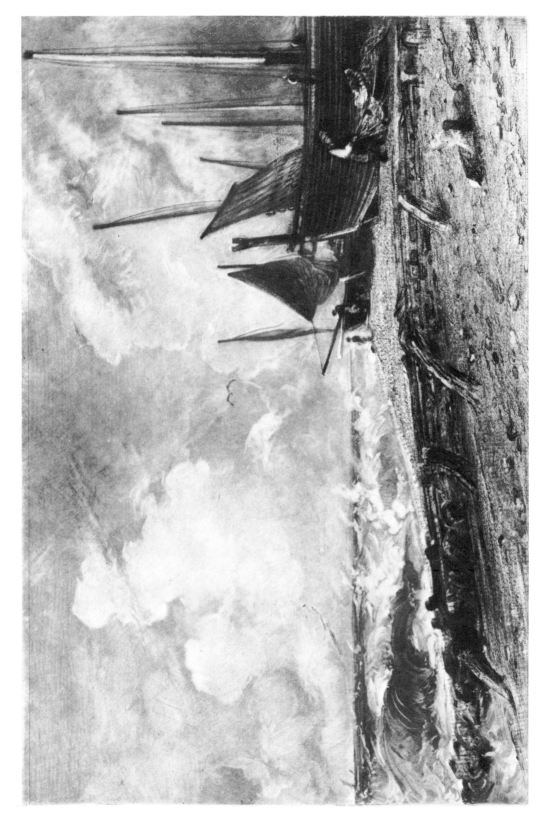

Plate 9 *continued*

Plate 10 *Old Sarum*
First issued in part two, 1830

the centre of the town, which prove what would have been the case had the country been planted. The want of shipping, or rather of their near approach, is compensated for by an advantage more than equal to the loss, as the point of Worthing to the West which keeps them distant, also prevents that accumulation of decaying weed on the shore, which forms so great an annoyance on many other coasts. Thus it will be seen that in this happily situated spot the Climate, the In-land Country and the Coast are equally propitious.

Alternative title
Mound of the City of Old Sarum.
Symbol g
Original V & A (R 332);
see also watercolour of 1834 (R 359, T 311).
Compare the second plate of this subject, issued in 1833, which is no.23 below.
Bibliography W 14; S 83
Slightly reduced

OLD SARUM

'The pomp of Kings, is now the Shepherd's humble pride.'

In no department of Painting is the want of its first attractive quality, 'General Effect,' so immediately felt, or its absence so much to be regretted, as in Landscape; nor is there any class of Painting, where the Artist may more confidently rely on the principles of 'Colour' and 'Chiar' oscuro' for making his work efficient. Capable as this aid of 'Light and Shadow' is of varying the aspect of everything it touches, it is, from the nature of the subject, nowhere more required than in Landscape; and happily there is no kind of subject in which the Artist is less controlled in its application: he ought, indeed, to have these powerful organs of expression entirely at his command, that he may use them in every possible form, as well as that he may do so with the most perfect freedom; therefore, whether he wishes to make the subject of a joyous, solemn, or meditative character, by flinging over it the cheerful aspect which the sun bestows, by a proper disposition of shade, or by the appearances that beautify its rising or its setting, a true 'General Effect' should never be lost sight of by him throughout the production of his work, as the sentiment he intends to convey will be wholly influenced by it.

The subject of this plate, which from its barren and deserted character seems to embody the words of the poet – 'Paint me a desolation,' – is grand in itself, and interesting in its associations, so that no kind of effect could be introduced too striking, or too impressive to portray it; and among the various appearances of the elements, we naturally look to the grander phenomena of Nature, as according best with the character of such a scene. Sudden and abrupt appearances of light, thunder clouds, wild autumnal evenings, solemn and shadowy twilights, 'flinging half an image on the straining sight,' with variously tinted clouds, dark, cold, and gray, or ruddy and bright, with transitory gleams of light; even conflicts of the elements, to heighten, if possible, the sentiment which belongs to a subject so awful and impressive.

'*Non enim hic habemus stabilem civitatem.*' The present appearance of Old Sarum – wild, desolate, and

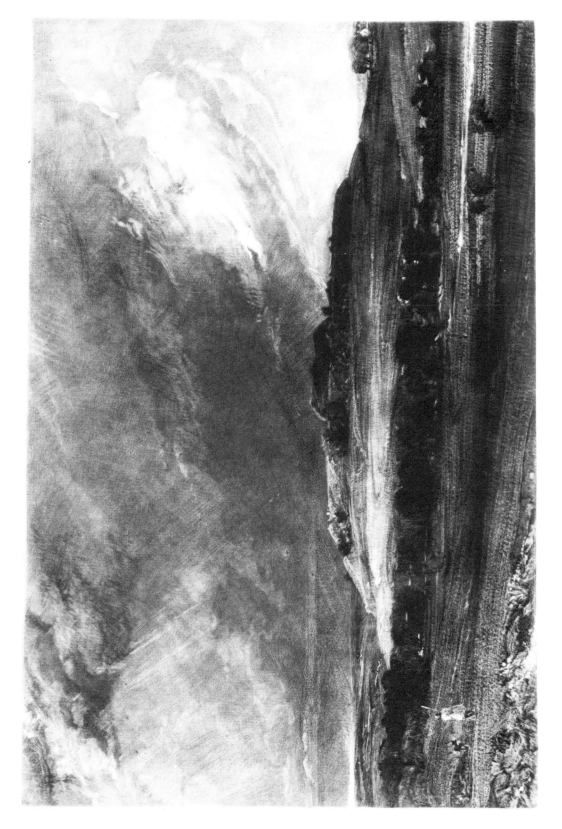

Plate 10 *continued*

Plate 11 *Summer Morning (Dedham Vale)*

First issued in part three, 1831
1842-12-10-122

dreary – contrasts strongly with its former greatness. This proud and 'towered city,' once giving laws to the whole kingdom – for it was here our earliest parliaments on record were convened – can now be traced but by vast embankments and ditches, tracked only by sheep-walks: 'The plough has passed over it.' It was on this spot the wily Conqueror, in 1086, confirmed that great political event, the establishment of the feudal system, which enjoined the allegiance of the nobles; other succeeding monarchs held their courts here, but during these periods, much must always be involved in that almost impenetrable gloom, which clouds the dark history of our Middle Ages; yet, doubtless, many were the ruthless acts of tyranny and deeds of violence perpetrated on this far-famed mount, but which have, alike with their agents, sunk into that repose of which its present appearance presents so striking an image. In the days of chivalry, it poured forth its Longspees and other valiant knights over Palestine. It was the seat of the ecclesiastical government, when the pious Osmond and the succeeding bishops diffused the blessings of religion over the western part of the kingdom; thus it became the resort of ecclesiastics and warriors, 'Of throngs of knights and barons bold,' till their feuds, and mutual animosities, augmented by the insults of the soldiery, at length caused the separation of the clergy, and the transfer of the cathedral from within its walls, which took place in 1227, and this event was followed by the removal of the most respectable inhabitants. In less than half a century after the completion of the new church, the building of a bridge adjoining it over the river at Harnham diverted the great western road, and turned it from the old through the new city. This last step completed the desertion, and led to the final decay of Old Sarum. The site now only remains of this once proud and populous city, whose almost impregnable castle, and lofty and embattled walls, whose churches, and even every vestage of human habitation, have long since passed away.

The beautiful imagination of the poet Thomson, when he makes a spot like this the haunt of a shepherd with his flock, happily contrasts the playfulness of peaceful innocence with the horrors of war and bloodshed, of which it was so often the scene:–

'Lead me to the mountain's brow,
Where sits the shepherd on the grassy turf
Inhaling healthful the descending sun.
Around him feeds his many-bleating flock,
Of various cadence; and his sportive lambs,
This way and that convolv'd, in friskful glee,
Their frolics play. And now the sprightly race
Invites them forth; when swift the signal giv'n
They start away, AND SWEEP THE MASSY MOUND
THAT RUNS AROUND THE HILL, THE RAMPART ONCE
OF IRON WAR' in ancient barbarous times,
When disunited BRITAIN ever bled.

Alternative titles
Summer Morning. Harwich Harbour in the distance;
Summer Morning. The Home-Field. Dedham.
Symbol L or LP
Original oil sketch of *c.*1830 or perhaps earlier, V&A (R 332).
Bibliography W 6; S 26
Slightly reduced

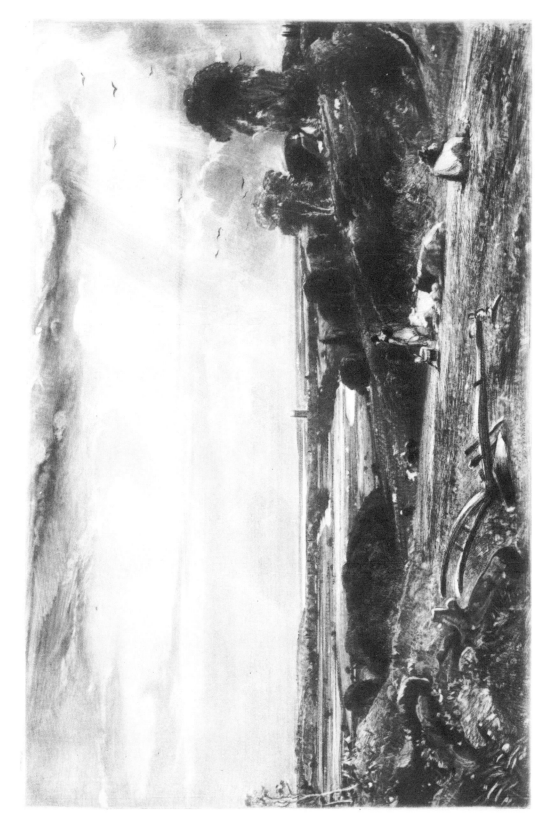

Plate 12 *Summer Evening*
First issued in part three, 1831

Alternative titles
Summer Evening. Cattle Reposing;
Summer Evening. Cattle Reposing.
East Bergholt.

Symbol p or FP

Original oil sketch of *c.*1809–11, V & A
(R 98).

Bibliography W 7; S 6.

Slightly reduced

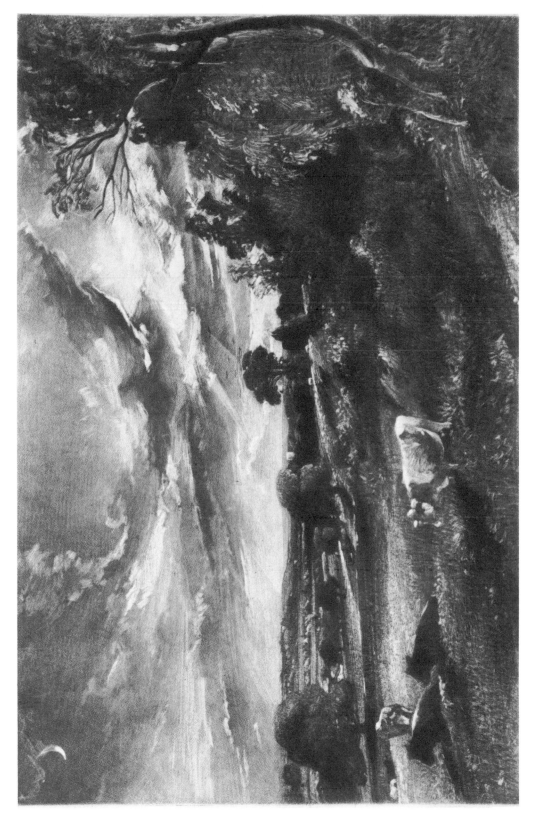

Plate 13 *Mill Stream*
First issued in part three, 1831
1842-12-10-144

Alternative titles
River Stour, near Flatford Mill.
Afternoon;
River Stour, near Flatford Mill.
Symbol p
Original painting of *c*.1814, collection
of Ipswich Borough Council (T 129).
Bibliography W 12; S 25

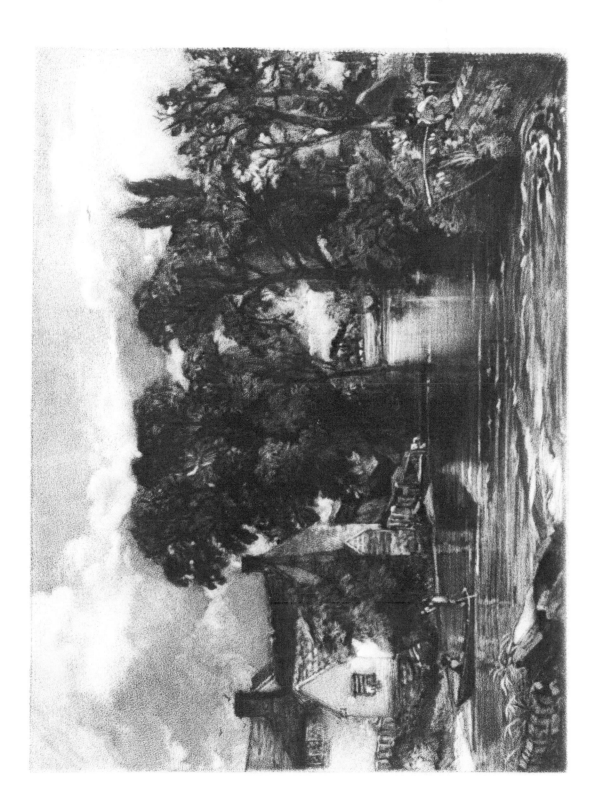

Plate 14 *A Heath (Hampstead Heath: Branch Hill Pond)*

First issued in part three, 1831

Alternative titles
Hampstead Heath. Sand Pits. Storm approaching;
Hampstead Heath. Stormy noon.

Symbol g or GP

Original painting of 1828, V & A (R 301).

Bibliography W 8; S 23

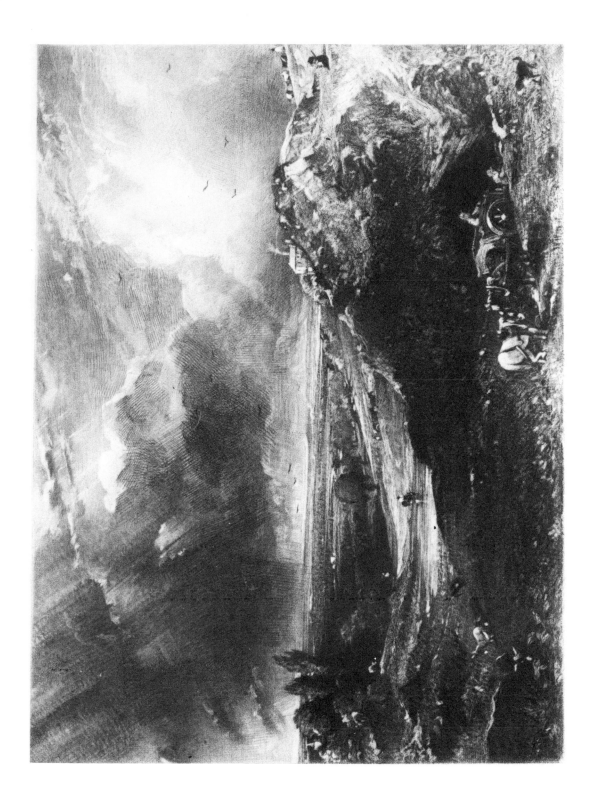

Plate 15 *A Summerland (Ploughing in Suffolk)*

First issued in part four, 1831

1842-12-10-107

Alternative titles
A Summerland. Rainy Day. Ploughmen;
Summerland. Rainy Day. The Ploughman.

Symbol p

Original painting of 1814, UK private collection (T 123); there is another version in the Paul Mellon collection, Yale Center for British Art.

Bibliography W 15; S 10

Slightly reduced

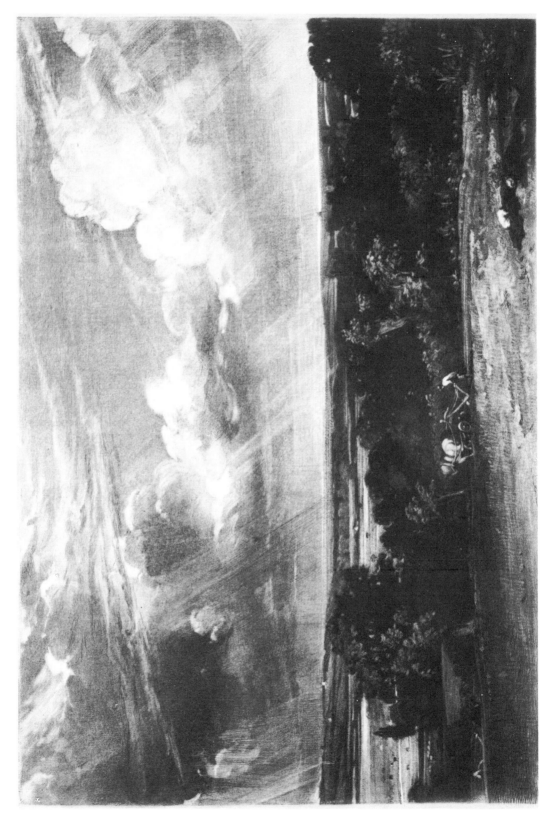

Plate 16 *River Stour, County of Suffolk (View on the Stour)*

First issued in part four, 1831

Alternative titles
Barges on the River Stour, Suffolk;
Scene on the River Stour, Suffolk.

Symbol pf

Original painting of 1822,
Henry E. Huntington collection, San
Marino; see also full size sketch for painting of
1822, Royal Holloway College
(T 201).

Bibliography W 5; S 19

Slightly reduced

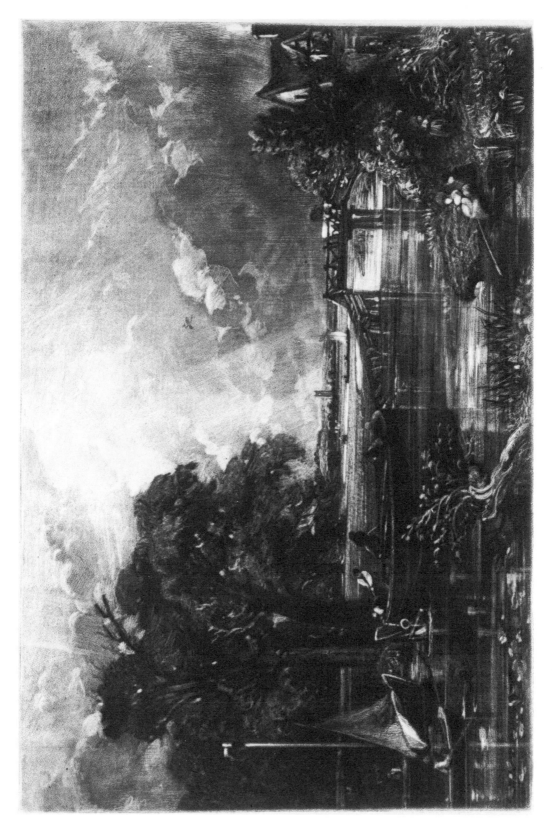

Plate 17 *Summer Afternoon - After a Shower (Windmill at Redhill)*

First issued in part four, 1831

Alternative title
Summer Afternoon. Sunshine after a Shower.

Symbol L

Original oil sketch of ?1824, Tate Gallery, no.1815. (On 23 March 1831 Constable wrote that he had 'formed the wish to add a Windmill to the set'; this plate probably resulted from the decision.)

Bibliography W 19; S 28

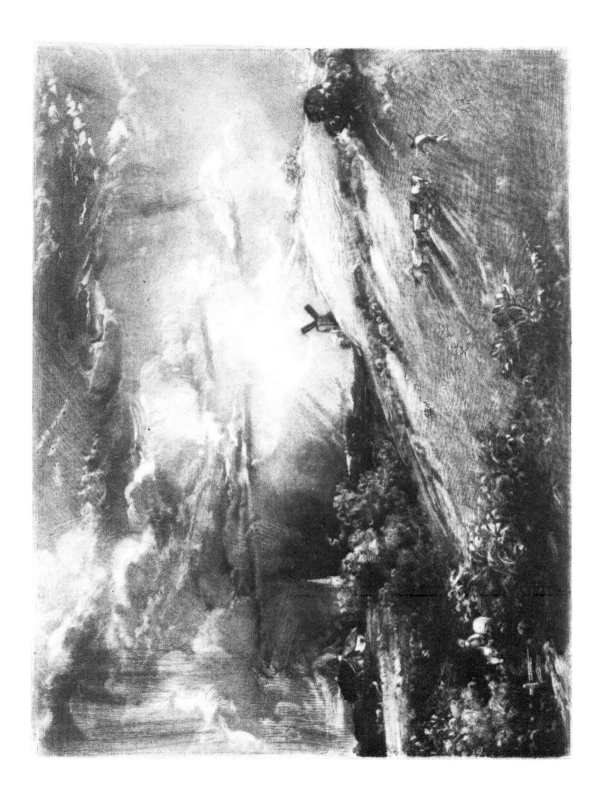

Plate 18 *A Lock on the Stour,*
County of Suffolk (Landscape: Boys
fishing)
First issued in part four, 1831

Alternative title
Head of a Lock, on the Stour.

Symbol pf

Original painting of *c*.1813, Anglesey
Abbey (T 118).

Bibliography W 13; S 20

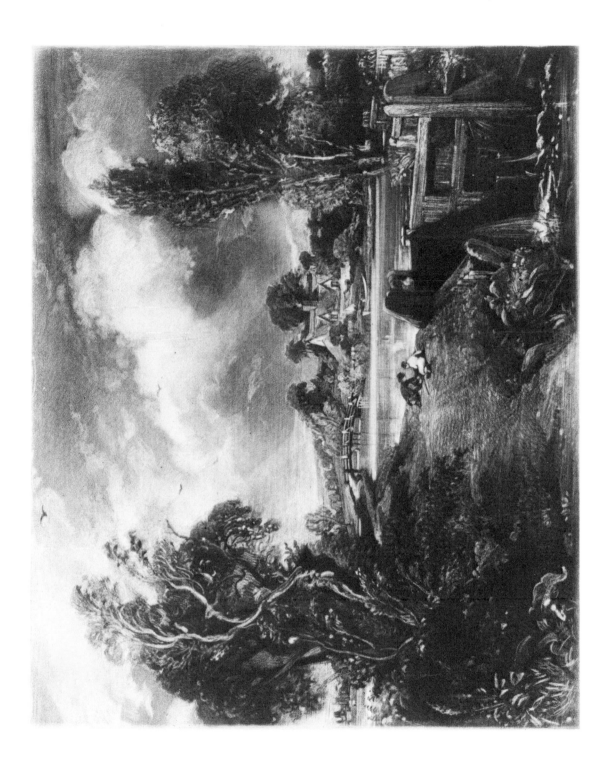

Plate 19 *Yarmouth, Norfolk*
First issued in part five, 1832

Alternative titles
Yarmouth Pier, Norfolk. Morning
Breeze;
Yarmouth Pier, Norfolk. Morning.
Symbol L
Original oil painting of *c.*1823, Tate
Gallery, no.2650 (T215).
Bibliography W10; S18
Slightly reduced

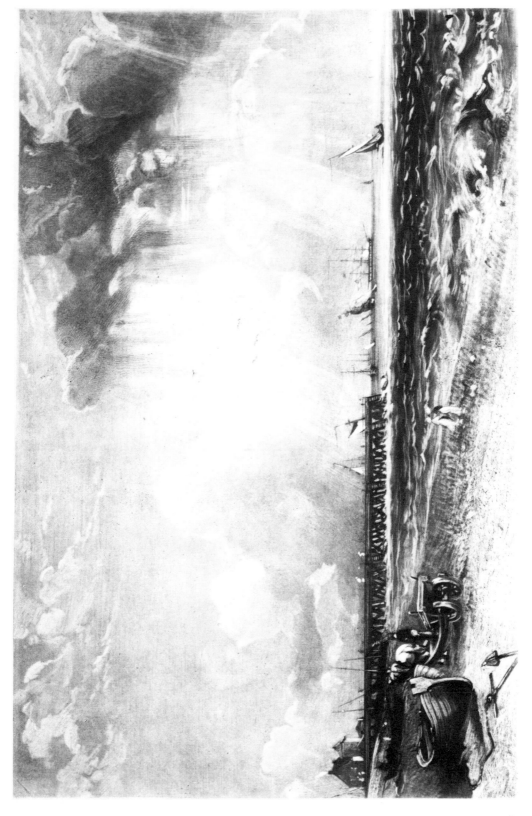

Plate 20 *Autumnal Sun Set*

First issued in part five, 1832,
(publication line date 1831)

Alternative title
Sunset. Peasants returning homeward.

Symbol L

Original oil sketch on paper, of *c.*1812,
V & A (R 120).

Bibliography W 3; S 14

Slightly reduced

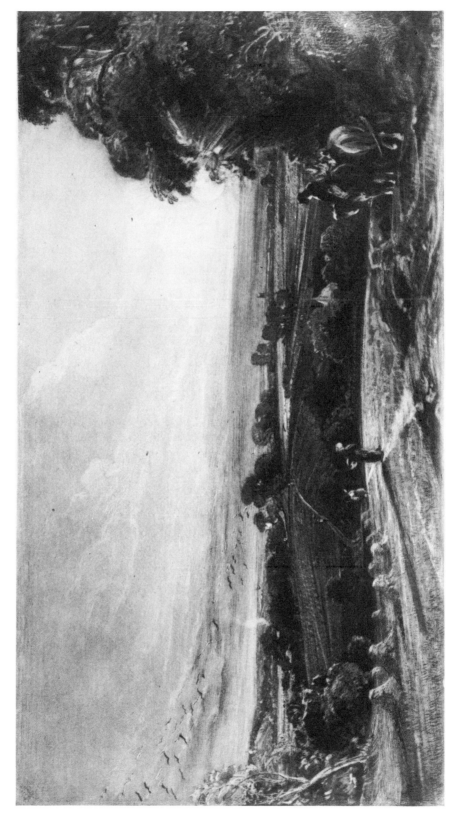

Plate 21 *The Glebe Farm*
First issued in part five, 1832

Alternative titles
The Glebe Farm and Green Lane. Girl
at the Spring;
The Glebe Farm. Girl at a Spring.

Symbol pl or Tp

Original painting exhibited 1835, but
executed earlier; in the Tate Gallery,
no.1274 (T321).
See also an oil sketch of *c.*1810–15
(R111) and the painting shown at the
British Institution, 1827.

See *Castle Acre Priory*, no.34 below,
the subject into which Constable
converted the first plate of *The Glebe
Farm*.

Bibliography W20; S29

Slightly reduced

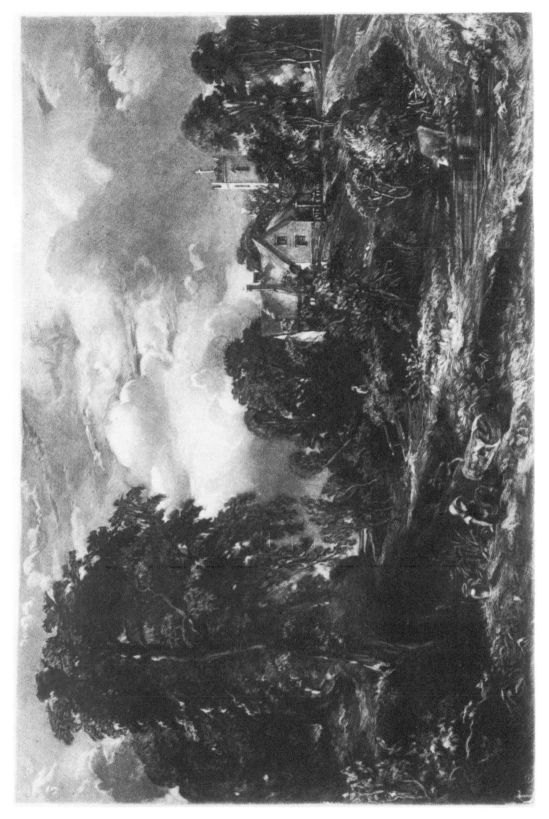

Plate 22 *Hadleigh Castle near the Nore*

First issued in part five, 1832
1842-12-10-49

Alternative titles
Hadleigh Castle, Mouth of the
Thames. Morning;
The Nore, Hadleigh Castle, Mouth of
the Thames.

Symbol g

Original painting of 1829, Paul
Mellon collection, Yale Center for
British Art (T263); see also full size
sketch, Tate Gallery, no.4810 (T261).

Bibliography W21; S34

Slightly reduced

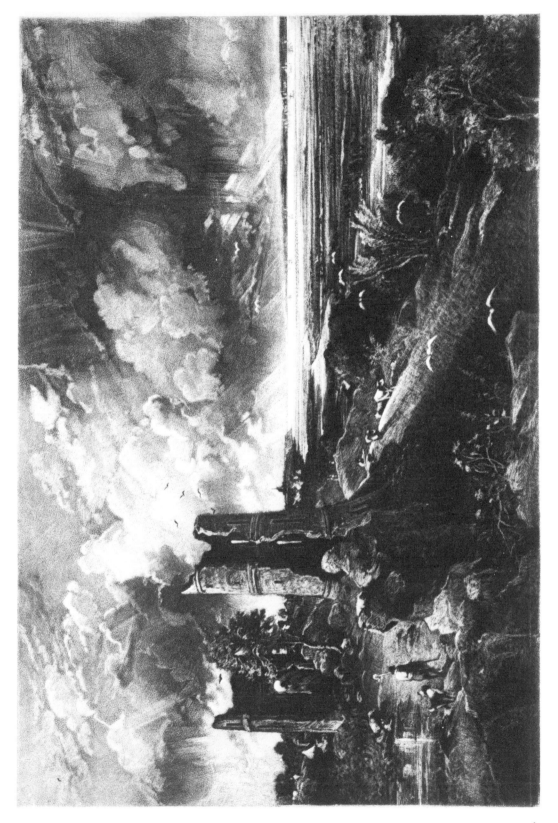

Plate 23 *Old Sarum (second plate)*

First issued in the second edition,
dated 1832
1842-12-10-127

Alternative title
Mound of the City of Old Sarum.
Evening.

Original oil sketch of *c*.1829, V&A
(R 322).
See first plate of the subject, no.10
above.

Bibliography S 32

Slightly reduced

Plates 24–37

Plates issued by Lucas in 1845

Plates 38–42

The Rare Unpublished Plates

Plates 24–37

Issued by Lucas
in 1845

Plate 24 *Porch of the Church at East Bergholt, Suffolk*
1846-11-14-26

Original oil sketch of 1811, Tate Gallery, no.1234 (T99).
Bibliography W 23; S 42

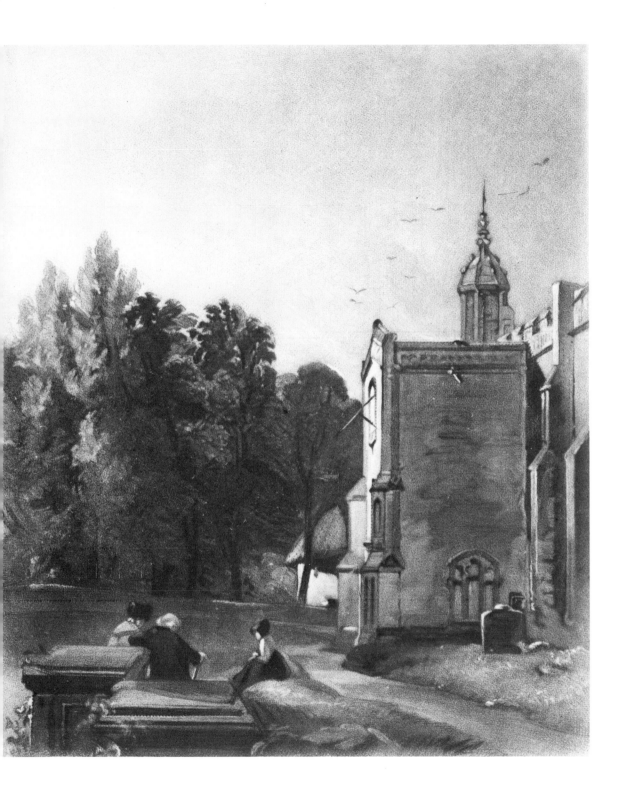

Plate 25 *Gillingham Mill,*
Dorsetshire
1846-1-30-31

Original oil painting of ?1827, V&A
(R 288).
Bibliography W 24; S 43

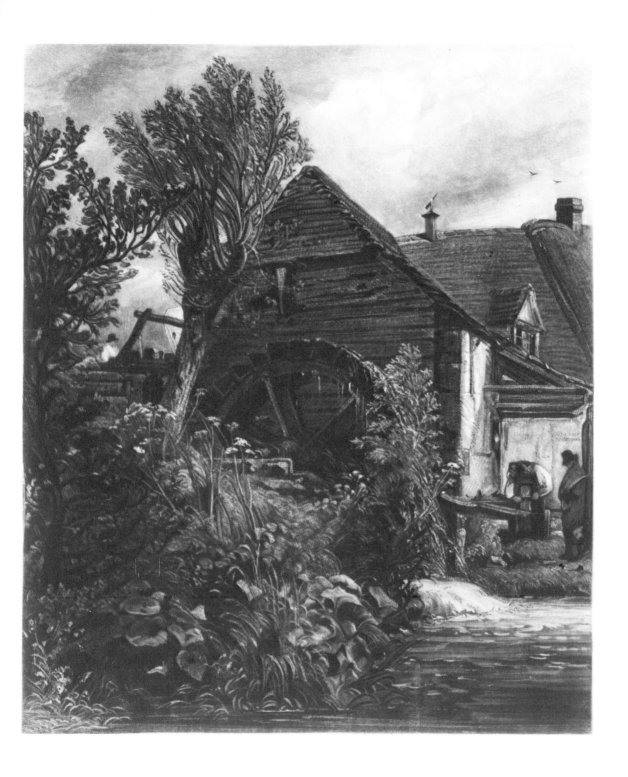

Plate 26 *Sir Richard Steele's Cottage, Hampstead*
1846-11-14-28

Original oil sketch, Paul Mellon collection, Yale Center for British Art.
Bibliography W 25; S 48

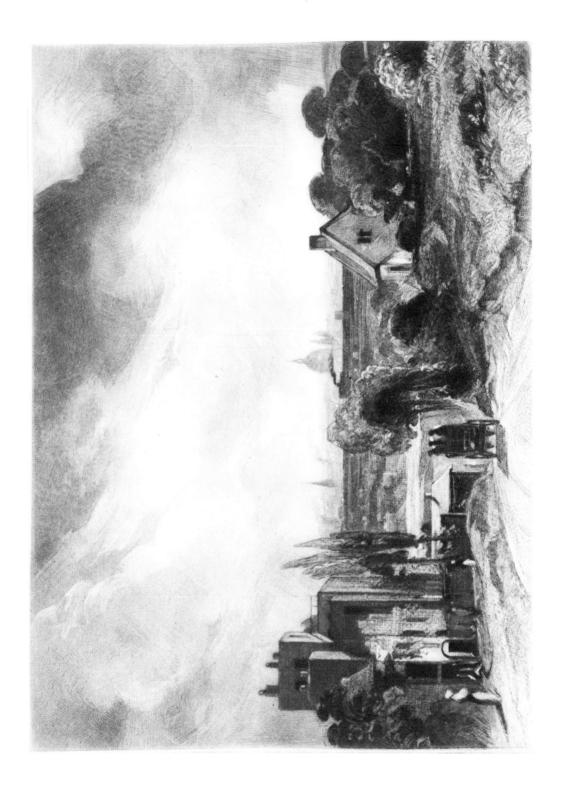

Plate 27 *Jacques and the wounded Stag*
1846-11-14-29

Symbol p, elsewhere Hp & f

Original watercolour drawing sold
Christie, 14 June 1977 (92) repr.;
Constable's preliminary sketch of the
subject is in the British Museum
(1865-12-9-534).

Bibliography W 26; S 15

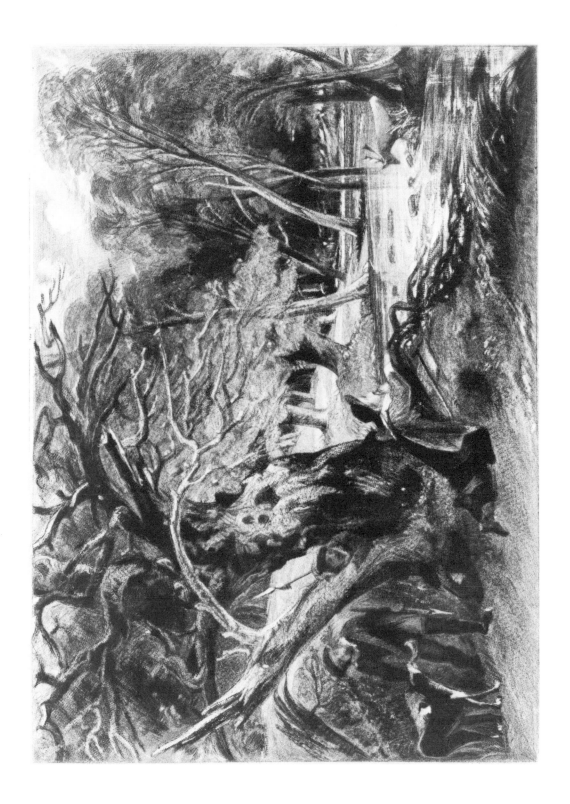

Plate 28 *Corn Fields near Brighton*
1846-11-14-30

Original an untraced oil sketch
formerly with the artist's family.
Bibliography W 27; S 44

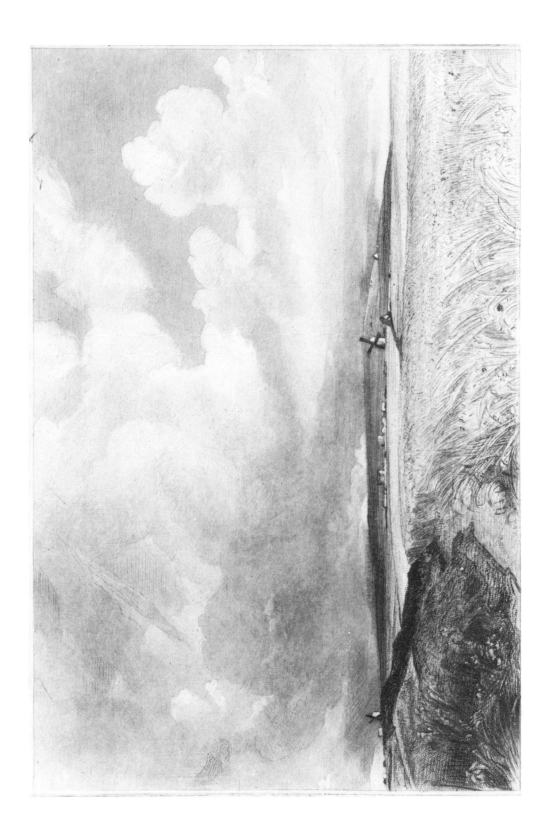

Plate 29 *Stonehenge, Salisbury Plain*
1846-11-14-31

Original watercolour drawing
formerly in the collection of
C. R. Leslie.

Bibliography W 28; S 41

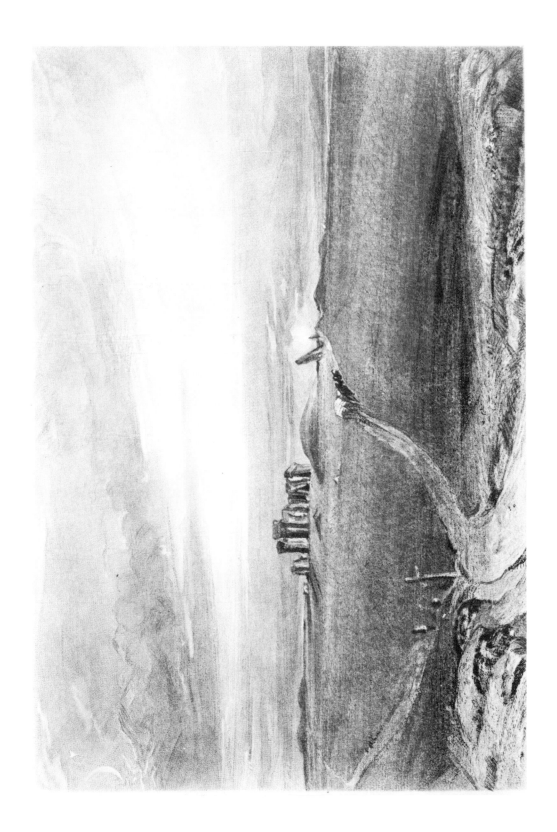

Plate 30 *Willey Lott's House, with
the Painter's Father*
1846-11-14-32

Symbol pf

Original probably the oil sketch on
canvas of *c.*1830, V&A (R 329a).

Bibliography W 29; S 33

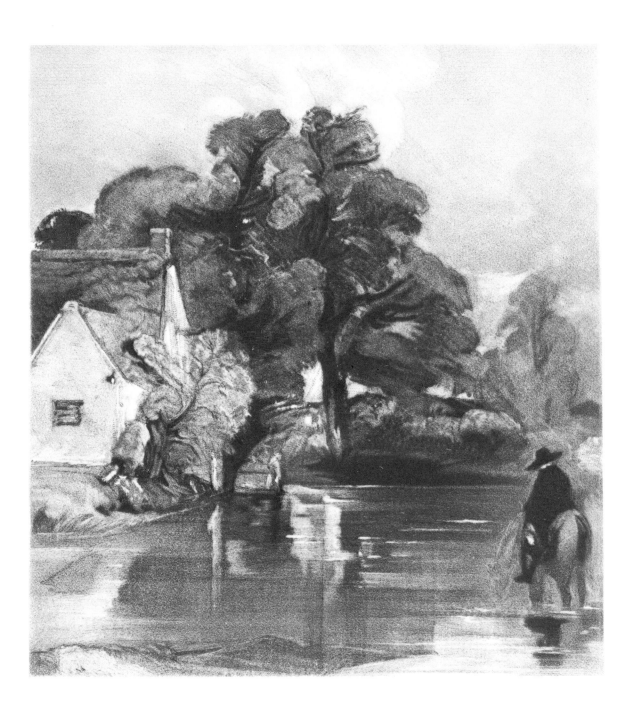

Plate 31 *A Cottage in the Corn Field*
(Woodman's cottage)

1846-11-14-33

Symbol p

Original oil painting exhibited RA
1817 (Private Collection); see also
later version of the subject, exhibited
1833, V&A (R 353, T 297) and the
pencil drawing of *c.* 1815, V&A
(R 145, T 136).

Bibliography W 30; S 45

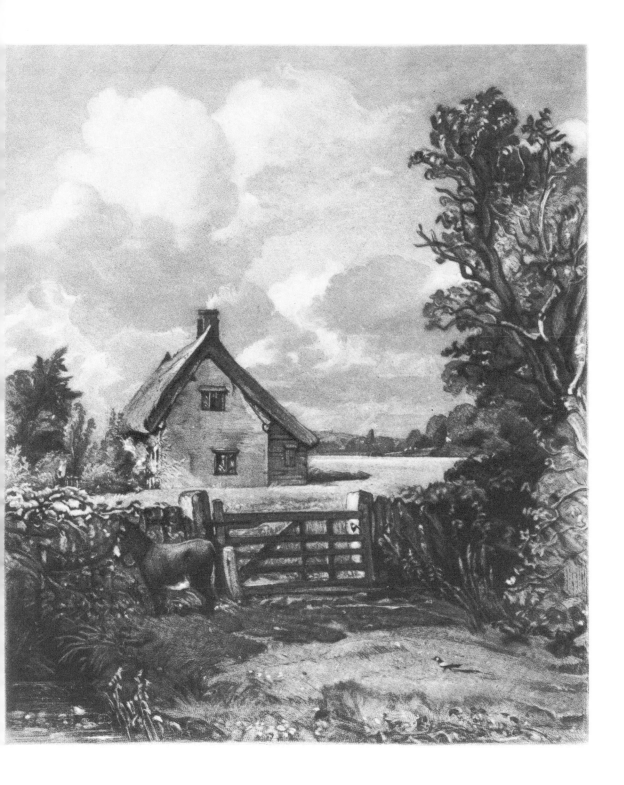

Plate 32 *Hampstead Heath, Harrow
in the Distance*

1846-11-14-34

Original oil painting formerly in the
Bullock collection, exhibited 1825;
see also the oil sketch on canvas,
V & A (R 333).

Bibliography W 31; S 47

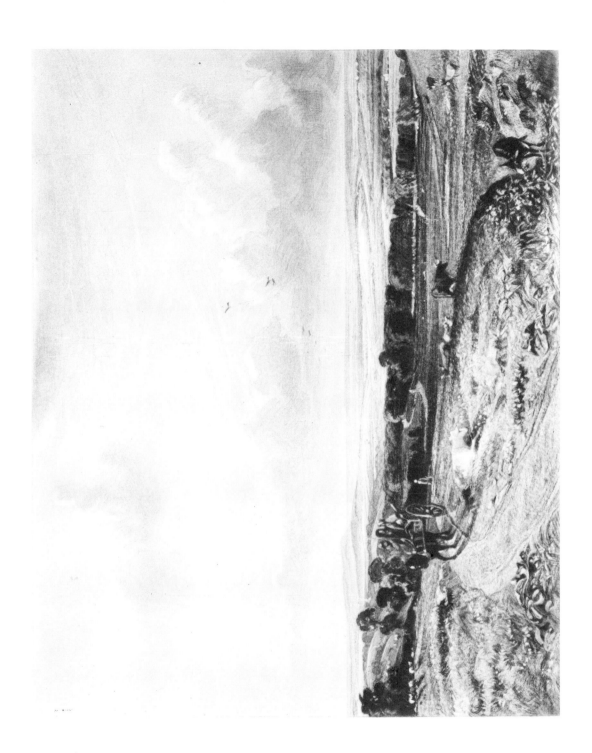

Plate 33 *Flatford, Suffolk*
1846-11-14-35

Original oil painting in the Tate
Gallery, no.1273 (T151).
Bibliography W32; S46

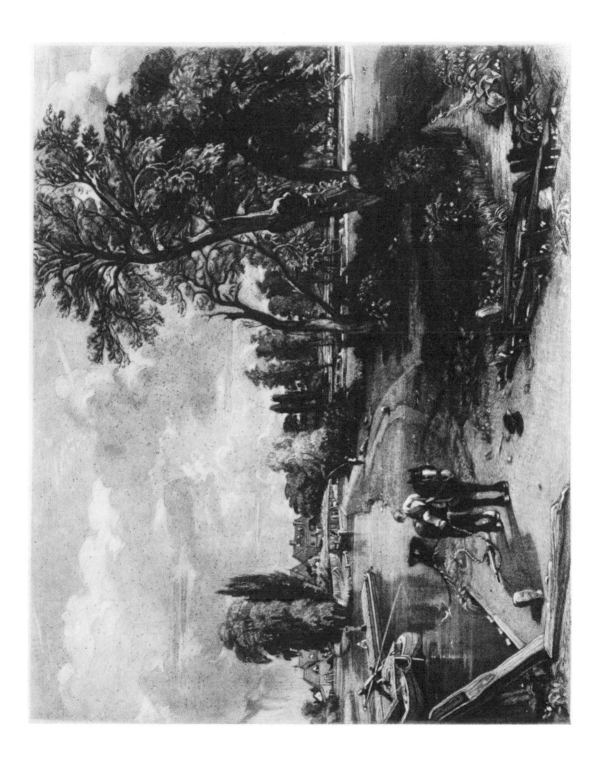

Plate 34 *Castle Acre Priory*
1846-11-14-36

Original see no.21 above.
The original *Glebe Farm* plate, altered
by Constable.
Bibliography W 33; S 22
Slightly reduced

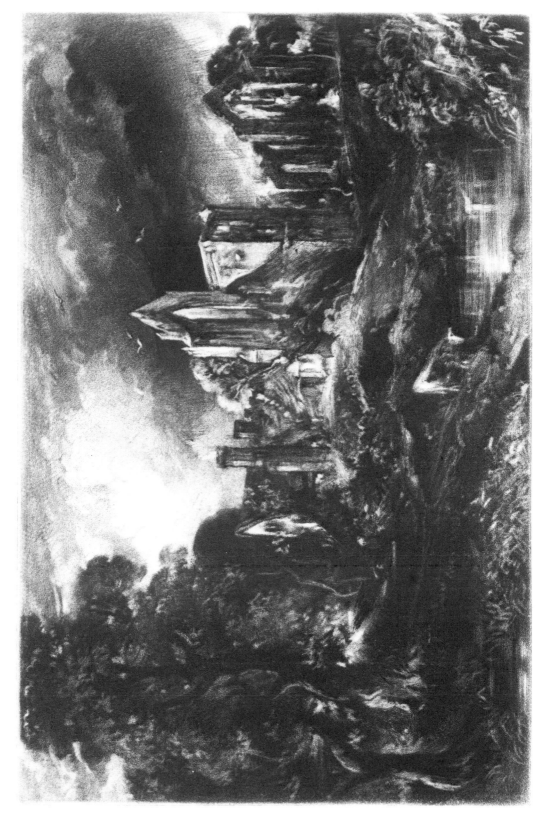

Plate 35 *View on the Orwell, Near Ipswich*

1842-12-10-21

Symbol g

Original oil sketch on millboard of *c.*1806–9, V & A (R 96).

Bibliography W 34; S 24
Slightly reduced

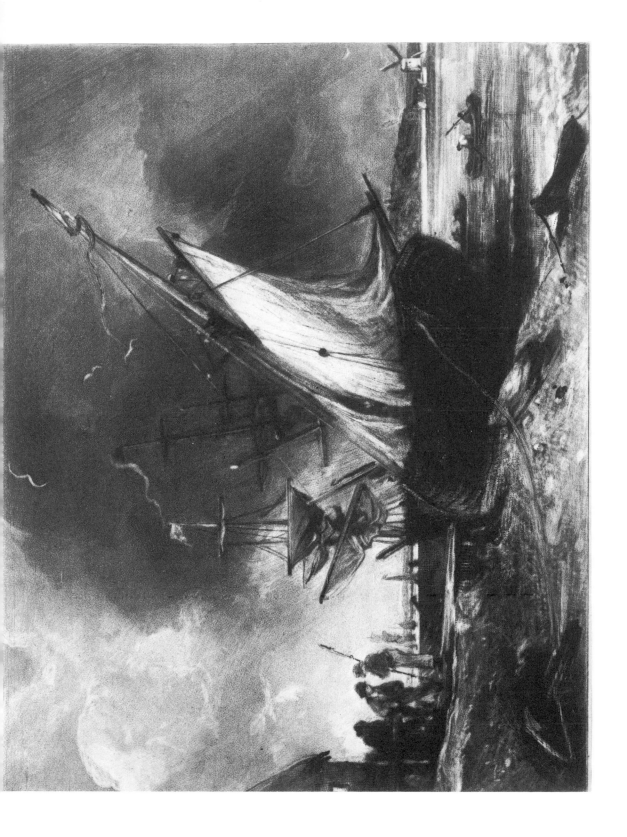

Plate 36 *Windmill near Colchester*
1846-11-14-38

Original watercolour drawing
formerly with the artist's family.
Bibliography W 35; S 50

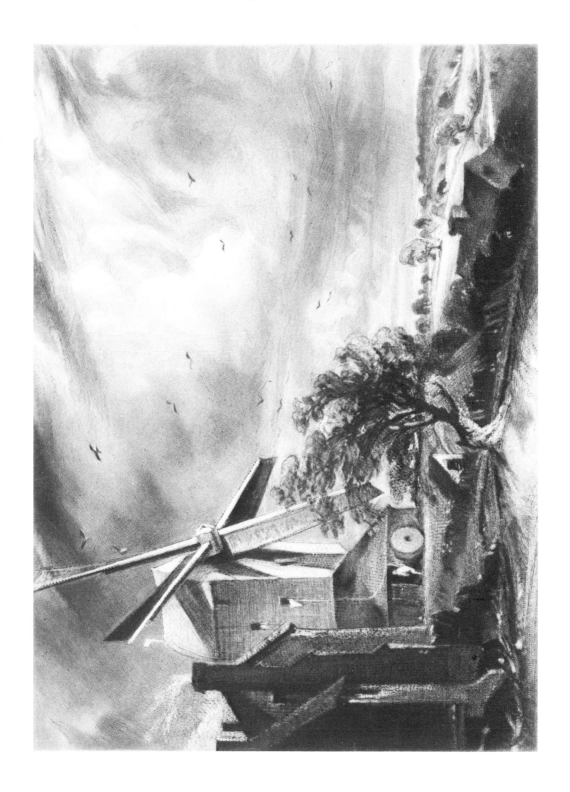

Plate 37 *Arundel Mill and Castle*
1846-11-14-39

Original oil painting of 1836/7, Toledo
Museum of Art (T335).
See also oil sketch on panel, De
Young Museum, San Francisco.
Bibliography W36; S49

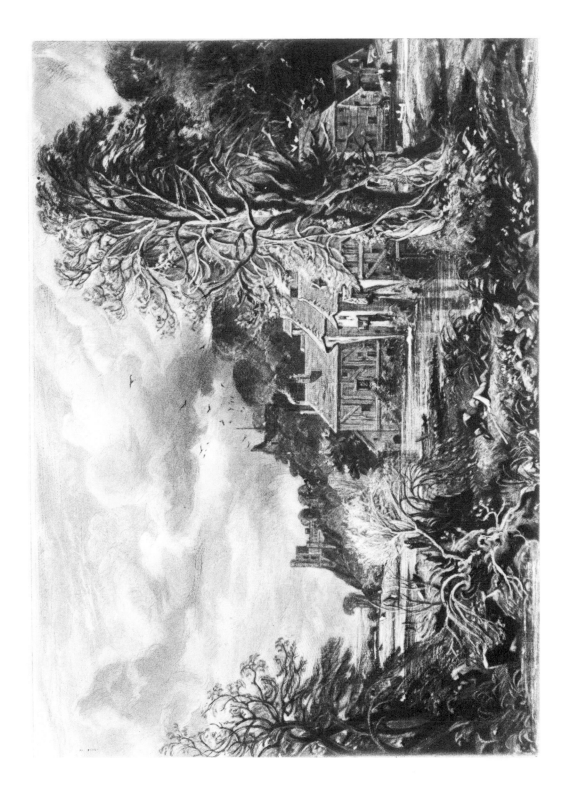

Plates 38–42

The Rare Unpublished Plates

Plate 38 *The opening of Waterloo Bridge, 16 June 1817*
1842-12-10-7

Symbol g

Original probably a sketch for the large painting exhibited in 1832, UK private collection; perhaps that now in the Paul Mellon collection, Yale Center for British Art; see also studies in pencil of *c.*1819, V&A (R 173), and private collection (T 174, 175) and an oil sketch on paper in the Royal Academy (T176).

Bibliography W 41; S 31

Slightly reduced

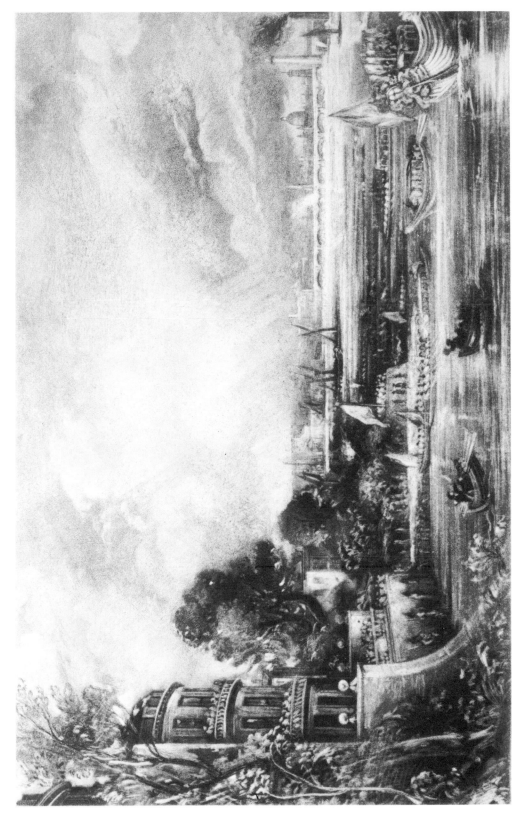

Plate 39 *Upright Mill, near Brighton*
1842-12-10-15

Original oil sketch on canvas of *c*.1828,
V & A (R 3 10).
Bibliography W 3 7; S 4

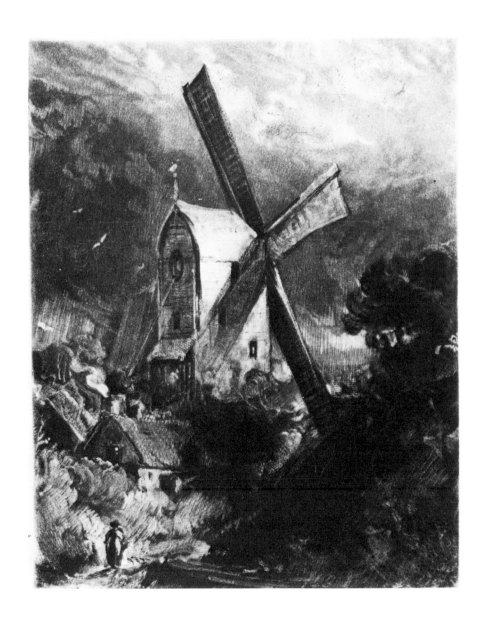

Plate 40 *The White Horse, River
Stour*

1842-12-10-11

Symbol pt or p

Original oil painting of 1819, Frick
Collection, New York.

Bibliography W 38; S 21

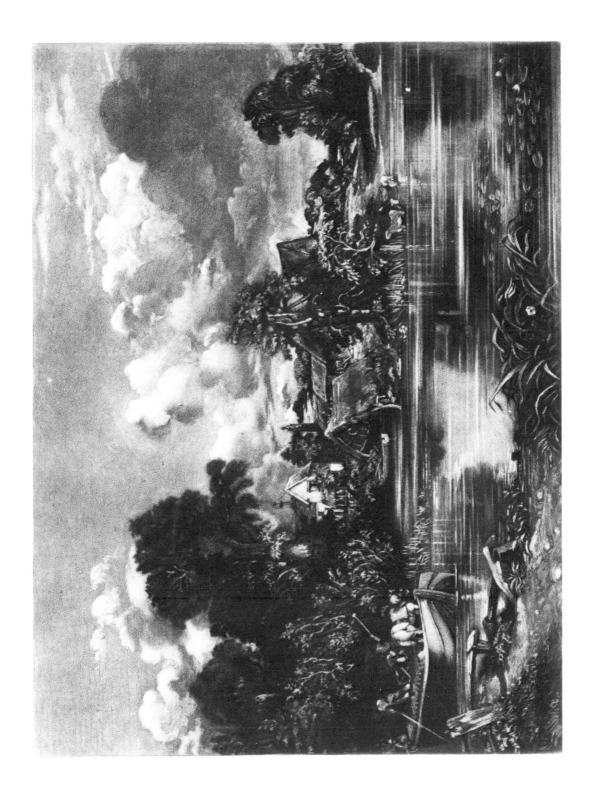

Plate 41 *Salisbury Cathedral*
1842-12-10-37

Symbol l or fyg; p
Original probably an untraced sketch
for the large oil painting *Salisbury
Cathedral, from the Meadows* of 1831
now in the collection of Lord Ashton
of Hyde (T 282).
See also an oil sketch in the Tate
Gallery, no.1814.
Bibliography W 40; S 30

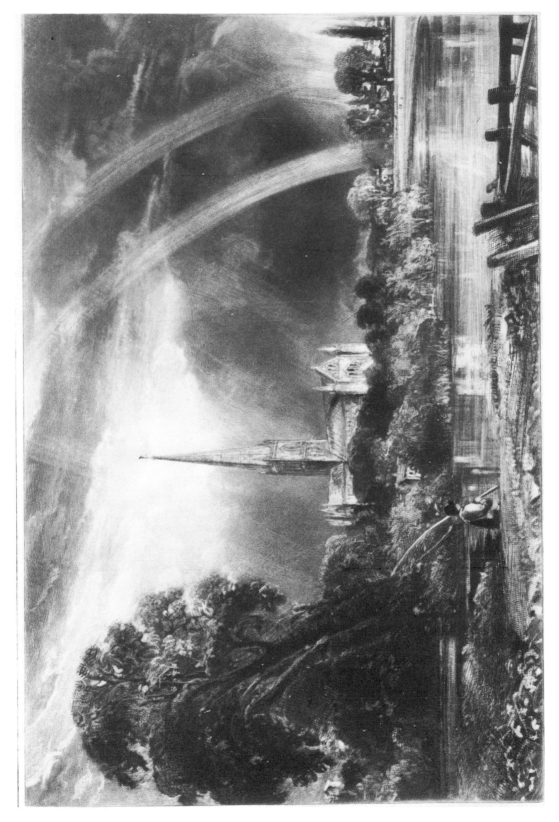

Plate 42 *The Bathers, Hampstead Heath*

1898-11-23-5

Original untraced
Bibliography W 39; S 51

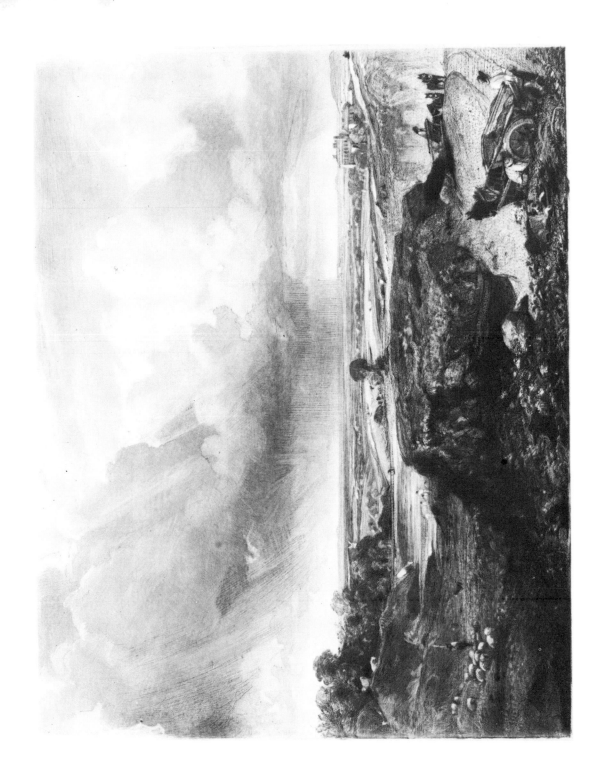